NEW YORK'S
GREATEST BOXERS

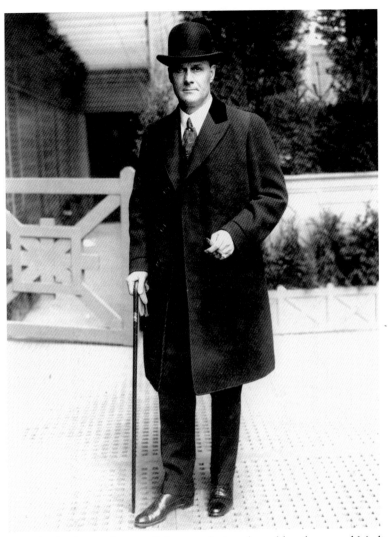

George "Tex" Rickard, who made a small fortune during the gold rush, turned Madison Square Garden into the mecca of boxing. He gained the promotional rights to stage boxing there after boxing was legalized in New York. His promotions were the first to draw million-dollar gates. The old Madison Square Garden was referred to as the "house that Rickard built." He also formed the New York Rangers hockey team, which got its name from Tex, who was a former Texas Ranger. (Pugilistica.com collection.)

On the front cover: Heavyweights Floyd Patterson and Ingemar Johansson slug it out during one of their three fights for the heavyweight title. Patterson took two out of three from the hard-hitting Swede. (Pugilistica.com collection.)

On the back cover: Please see page 31. (Pugilistica.com collection.)

Cover background: Please see page 20. (Pugilistica.com collection.)

NEW YORK CITY'S GREATEST BOXERS

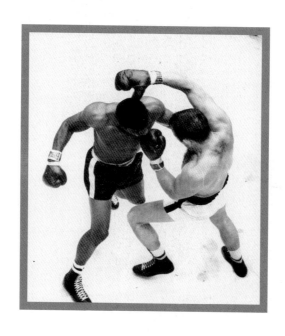

Jose Corpas

Copyright © 2006 by Jose Corpas
ISBN 0-7385-4901-0

Published by Arcadia Publishing
Charleston SC, Chicago IL, Portsmouth NH, San Francisco CA

Printed in the United States of America

Library of Congress Catalog Card Number: 2006930221

For all general information contact Arcadia Publishing at:
Telephone 843-853-2070
Fax 843-853-0044
E-mail sales@arcadiapublishing.com
For customer service and orders:
Toll-Free 1-888-313-2665

Visit us on the Internet at www.arcadiapublishing.com

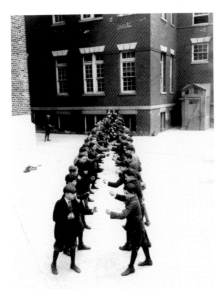

New York City public school students line up to practice their boxing drills. Boxing was taught as self defense at many schools during the 1920s. Boxing was also a collegiate sport from the 1920s until the 1950s. Some colleges even offered boxing scholarships. Some students have recently tried to revive interests by organizing matches between opposing schools. (Photography collection, Miriam and Ira D. Wallach Division of Art, Prints and Photographs, the New York Public Library, Astor, Lenox and Tilden Foundations.)

CONTENTS

Acknowledgments		6
Introduction		7
1.	The Heavyweights	9
2.	The Light Heavyweights	33
3.	The Middleweights	41
4.	The Welterweights	65
5.	The Lightweights	83
6.	The Featherweights	103
7.	The Bantamweights	115
8.	The Flyweights	123

ACKNOWLEDGMENTS

Since no major project is the result of one person, there are always many people whose help needs to be acknowledged. The majority of images appearing in this book are from the excellent collection of Dave Bergin at Pugilistica.com. Lou Manfra of Heavyweightcollectibles.com was also a big help and a pleasure to deal with. Alex Ramos and Jacquie Richardson, who continue to do great things with the Retired Boxers Foundation, were both very accommodating. Writer and film producer F. Daniel Somrack provided useful advice. I also appreciate the helpfulness of the *New York Daily News* photograph department. Thank you to my editor at Arcadia Publishing, Tiffany Howe, who knew just how to make things flow smoothly. And last but not least, a big thank-you to my wife and best friend, Terrie Tsang. Without her computer skills, I would not have been able to type a single word.

I also wish to acknowledge those who inspired me in one way or another to put this collection together. My father, Dave, and his best friend, Harry Lewis, are no longer with us, but their reminiscing of the good old days got me interested in what went on in the past. And I cannot leave out my uncle, Ruben Rivera, who was also a part of those conversations whenever he could make it out from Lindenhurst. Tony Pellone, the former contender, let me tag along with him when I was a teenager and introduced me to some of the best, like Jake LaMotta and Rocky Graziano. He also filled me in on the type of behind-the-scenes activities that never made it to print.

INTRODUCTION

The first New York City–born boxer to win a world championship was Tom "Spider" Kelly, who gained universal recognition as bantamweight champion on January 31, 1890. For the next 100 years, New York continued to produce numerous world champions and outstanding contenders. This book pays homage to all of the individuals who made the first century of boxing in New York an unforgettable one.

Boxing endured many difficulties during its inception. It was an illegal sport, and many of its participants were arrested. The matches that did take place did so only under the guise of exhibitions. Boxing became legal in New York under the Frawley Law, which permitted contests but did not allow any official decisions to be rendered. If a fight did not end in a knockout, the result stood as a no-decision. This was done to prevent gambling, but gamblers found a way around it by using the next day's newspaper reports. The dailies would describe the bout and then state who they felt won the bout. The trouble with this is that many of the reporters were offered gratuities in exchange for a favorable write-up. In recent years, many historians, frustrated with the amount of no-decisions on a boxer's record, have begun using the newspaper reports and have included the results as part of a boxer's record, as a "newspaper decision."

The Frawley Law was rescinded in 1917, and boxing was once again banned in New York. In 1920, New York state senate majority leader and future New York City mayor James J. Walker introduced the bill that would once and for all legalize boxing in New York under the Walker Law. During the 1920s, with the help of promoter Tex Rickard, boxing began to flourish. For the next few decades, the city was the center of the boxing world. Boxers such as Benny Leonard and Gene Tunney and later on, Sugar Ray Robinson, Jake LaMotta, and Rocky Graziano contributed to what was a golden age for boxing. Madison Square Garden became known as the mecca of boxing. Promoter Mike Jacobs, a New Yorker himself, took over as the premier promoter in boxing. He promoted such stalwarts as Joe Louis and Henry Armstrong. Boxing was flourishing under Jacobs until he suffered a stroke in 1946.

By the time of the fabulous 1950s, boxing began to fade as a dominant sport in New York and, subsequently, the entire United States. A recently formed organization, the International Boxing Club (IBC), which was headed by Jim Norris but allegedly controlled by mobster Frankie Carbo, began controlling the boxing matches at Madison Square Garden. Eventually the IBC would go on to dominate boxing in New York and if you did not play by their rules, you did not play at all. The scandals and corruption that ensued contributed to the dwindling popularity of boxing. Years later, the advent of casinos and the exorbitant fees they were able to pay for the right to host boxing matches took the focus away from the Big Apple and along with it, the status as the fight capital of the world.

But through it all, New York could always boast that many of the sport's finest operators were developed within its city limits. Hall of fame–bound practitioners like Floyd Patterson, Emile Griffith,

Carlos Ortiz, Jose Torres, and later, Mike Tyson, each added chapters to the rich boxing history of New York.

There is still a special aura that comes with performing in New York and Madison Square Garden. To this day, there are many world champions who would relish the opportunity to box there. The fighters appearing on these pages were selected because they are all a major part of the rich history of boxing in New York. But they are only a few of the many. I wish I had room to include every single one of them, but of course that is not possible. I also was restricted to including only those boxers whose photographs were available. I wish I could have included other boxers who were major players such as Paddy Young, Ben Jeby, Eddie "Cannonball" Martin, Lulu Perez, and Carmelo Costa, along with others like Murray Brandt, Al Reid, Johnny Turner, John Verderosa, and Vince "Pepper" Martin. The list goes on and on, and if I left anyone out, it was not intentional.

For the purposes of structure, this book deals only with the first 100 years of boxing under the Marquis of Queensberry, beginning with the coronation of New York's first champion, Tom "Spider" Kelly in 1890. Some outstanding boxers who came into prominence around the end of the first century of gloved boxing do not appear in this book. Among them are Aaron Davis, Kevin Kelly, Junior Jones, and Riddick Bowe. I also would like to state that all efforts were made to locate the copyright holders of some of the material used in this book. I apologize that it was not possible in many instances. If any information is provided, we will be sure to acknowledge it in future editions of this book.

1

The Heavyweights

The heaviest division in boxing has no maximum weight. Currently the minimum weight is 201 pounds. First recognized under the Marquis of Queensbury rules in 1882, the division originally included anyone above the middleweight division. After the formation of the light heavyweight class in 1903, the minimum weight became 176 pounds. In 1979, the cruiserweight division was created in the United States with a maximum weight of 190 pounds, which was recently upped to 200 pounds. Four New Yorkers claimed the title during the first 100 years. Gene Tunney was the first, followed by Jim Braddock, Floyd Patterson, and Mike Tyson in 1986. Jack Dempsey became a New Yorker later on in his career, and Riddick Bowe and Shannon Briggs were still a few years away from winning theirs. The city did not produce a champion in the cruiserweight division, although Wayne Braithwaite, a Guyanese fighting out of Brooklyn, has recently made it to the top.

There no doubt would have been more champions from the city if not for the ridiculously long and dominant title reigns of Jack Johnson, Jack Dempsey, Joe Louis, Muhammad Ali, and Larry Holmes. The five of them combined for a whopping 47 years at the top, completely dominating the first century. Add to that the short but dominant reigns of Rocky Marciano and Mike Tyson, and there just was not much room at the top for many of the contenders.

Roland LaStarza, Doug Jones, and Carl "the Truth" Williams had as much ability as any champion. Billy Daniels was a force to reckon with during the 1960s. Bob Stallings, who lived on Ocean Avenue in Brooklyn, beat Daniels, Chuck Wepner, Mac Foster, and Earnie Shavers. The heavyweights have always attracted the most attention, and the championship was at one time the most prestigious title in all of sports.

One of the first heavyweights from New York City to make his mark during the gloved era was Bartley Madden. Originally from Ireland, Madden got his start around 1912 and ended up tallying close to 80 fights. He battled the likes of Gene Tunney, Harry Greb, Battling Levinsky, Joe Jeannette, Tommy Gibbons, Billy Miske, Fred Fulton, fellow New Yorker John Lester Johnson, and Harry Wills. (Pugilistica.com collection.)

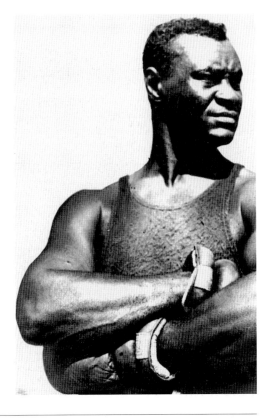

"The Black Panther" Harry Wills came from New Orleans and boxed in New York City over 20 times. He was denied a shot at the heavyweight championship because of his skin color. Champion Jack Dempsey agreed to fight him, but promoters either could not or would not come up with the money. Promoters feared that a Wills victory would make the heavyweight championship worthless. (Pugilistica.com collection.)

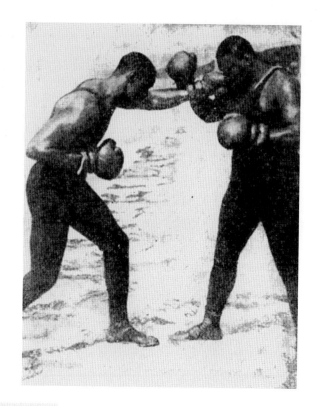

Wills, pictured here sparring with Battling Owen, won the colored championship from the great Sam Langford in 1914. He lost it to Langford later that year and then regained the claim in 1915 by beating another all-time great, Sam McVea. Wills continued to claim the championship until well into the 1920s. (Pugilistica.com collection.)

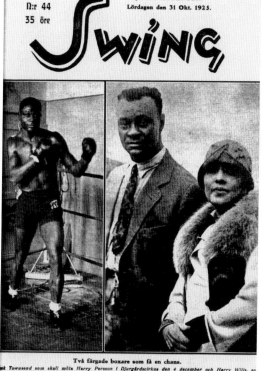

Wills and Jack Townsend are on the cover of the Swedish boxing magazine *Swing*. By the time of this 1925 issue, Wills's best days were behind him. He topped 100 bouts during his 21-year career, most of them against other black fighters in what was in essence an African American league of boxing. He boxed Sam Langford 22 times and had multiple bouts against Joe Jeannette and Sam McVea. (Pugilistica.com collection.)

NEW YORK CITY'S GREATEST BOXERS

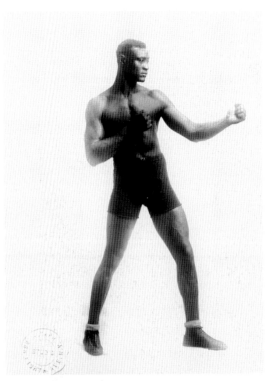

Harry Wills stood six feet four inches tall and weighed about 225 pounds during his prime. He fought the great Sam Langford 22 times, winning six and losing two, with the rest being no-decisions. Langford is considered by many to have been the greatest ever. (Pugilistica.com collection.)

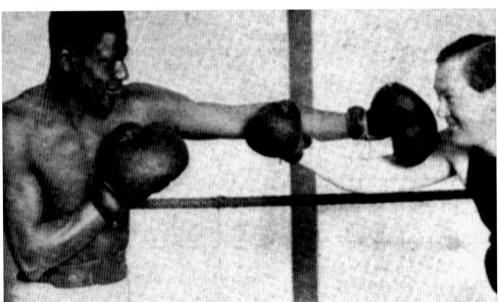

Jack Townsend, squaring off against an unidentified man, started boxing around 1920. He fought the great former champion Jack Johnson in 1921 at Leavenworth Federal Prison, where Johnson was serving time for violating the Mann Act. Townsend boxed throughout the United States as well as in Germany, Sweden, and the Caribbean. He battled Tiger Flowers, George Godfrey, and Battling Levinsky, among others. (Pugilistica.com collection.)

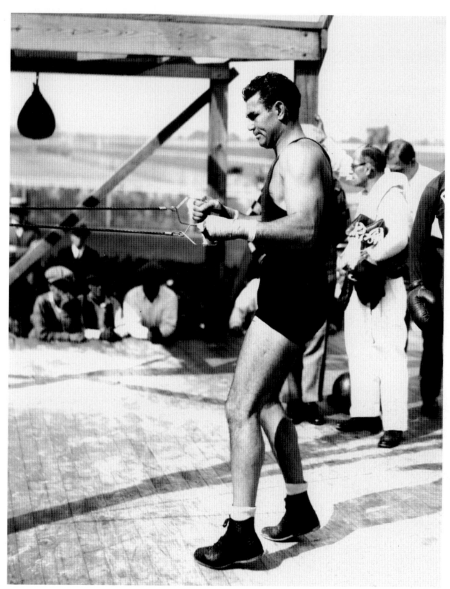

Jack Dempsey was one of the best boxers ever. His title defense against Georges Carpentier of France was the first boxing match to gross over $1 million at the gate. Born William Harrison Dempsey in Manassa, Colorado, Dempsey also lived in Utah before leaving home while still a teenager. Depending on the source, he either became a hobo or an itinerant worker, riding the rails in search of work. What is not disputed is that along the way he developed into one of the best boxers ever. Fast and aggressive, with a bob-and-weave style of fighting, he earned a shot at the title after an impressive string of first-round knockouts. Dempsey won the title from Jess Willard in 1919 and held it until 1926, when Gene Tunney outpointed him. He moved to New York City late in his career and opened a restaurant located at 1618 Broadway in Manhattan, which remained in business for decades. Dempsey died in 1983 and is buried in a South Hampton, New York, cemetery. (Pugilistica.com collection.)

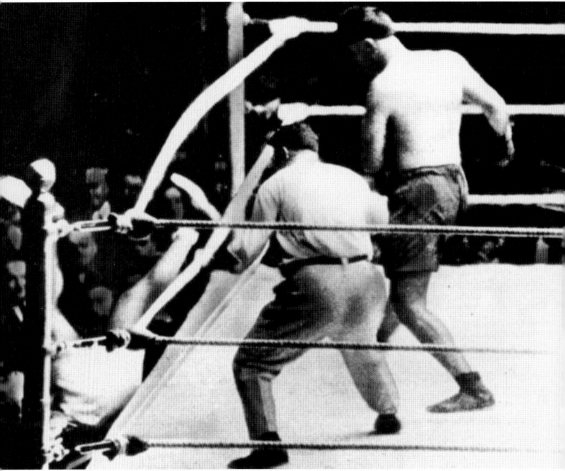

Luis Firpo, called the "Wild Bull of the Pampas," sends Jack Dempsey through the ropes and out of the ring during the first round of their September 14, 1923, bout at New York's Polo Grounds. The 82,000-plus fans in attendance witnessed one of the most spectacular bouts ever with a total of 12 knockdowns in just two rounds. Dempsey was the first to go down, but rose to floor Firpo seven times before being knocked out of the ring, landing on the typewriter of *New York Tribune* writer Jack Lawrence. Dempsey was hoisted back into the ring at the count of nine, although some clocked his time out of the ring at 14 seconds. Dempsey recovered and dropped Firpo three more times in the second round to win the fight by knockout. Firpo became a lifelong hero in his native Argentina as well as other Latin American countries. One of El Salvador's top soccer teams, Luis Angel Firpo, is named after him. (Pugilistica.com collection.)

Harry Wills and Firpo square off at the weigh-in and pose in the ring just before their September 11, 1924, bout in Jersey City, New Jersey. Wills weighed in at 217 pounds to Firpo's 224. It was an uneventful bout won by Willis. The press used this angle to undermine Wills's worth as the leading challenger, but Dempsey's promoter, Tex Rickard, had considerable influence over many writers and it is likely that he influenced some of the writings. Wills's routine victory over Firpo was in stark contrast to Dempsey's life-and-death struggle with Firpo just one year earlier. Wills, 35 at the time, was beyond his best years. He fought seven more times over the next eight years. Firpo fought twice more before retiring in 1926. He made a comeback in Argentina 10 years later. (Pugilistica.com collection.)

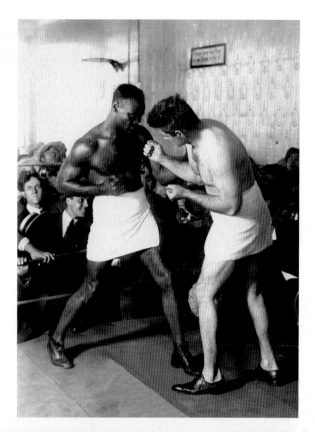

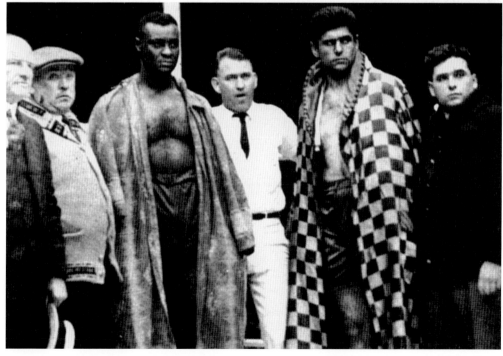

NEW YORK CITY'S GREATEST BOXERS

Gene Tunney was American Expeditionary Forces champion while serving in Europe. He became the first New Yorker to win the heavyweight championship when he outboxed Jack Dempsey. He was a master boxer who studied his opponent's style, looking for flaws or tendencies that he could exploit. Born in the Greenwich Village section of New York, he got his start in boxing at the local athletic club. During World War I, the Washington Street resident enlisted in the Marines. Known as "the Fighting Marine," he cleaned out the light heavyweight division and then moved up and defeated the legendary Jack Dempsey in 1926. He boxed from 1915 until 1928, engaging in 83 bouts, and lost only once. He retired in 1928 while still heavyweight champion. He was erudite and well read and was a published writer. Tunney was an avid reader of Shakespeare. (Pugilistica.com collection.)

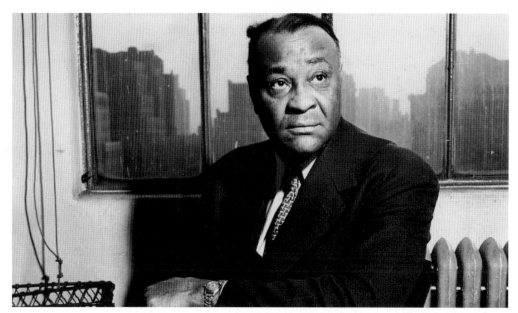

Harry Wills stayed in New York City after his fighting days were over. He operated a successful real estate business in Harlem. He died on December 21, 1958, of diabetes and was buried in Woodlawn Cemetery in the Bronx. Wills, probably the most famous of the uncrowned champions, was confident he would have been champion if given the opportunity against Dempsey, who he never blamed and later befriended. (Pugilistica.com collection.)

In this photograph of Jack Dempsey's training camp, one gets a nice view of an Everlast boxing dummy. Everlast was founded in the Bronx in 1910 by Jacob Golomb as a manufacturer of swimwear. Golomb later expanded to include sports equipment, but it was Dempsey who introduced Everlast to boxing. Dempsey asked Golomb to develop headgear that could withstand the rigors of training. Everlast soon became synonymous with boxing. (Pugilistica.com collection.)

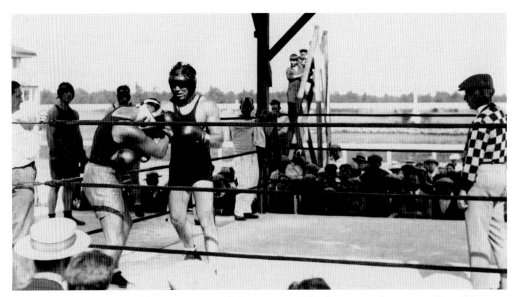

Jack Dempsey is pictured here sparring while preparing for his rematch against Gene Tunney. To the left of the ring are two other sparring partners awaiting their turn to spar with the former champion. While Dempsey never defended his title against black boxers, he hired many to serve as his sparring partners and none accused Dempsey of being prejudiced against them. (Pugilistica.com collection.)

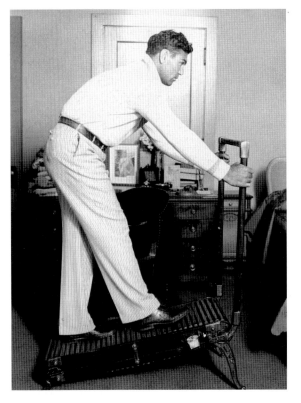

Dempsey takes time out to pose on a treadmill. Dempsey was in training for his rematch with Tunney when this photograph was taken in 1927. Dempsey was inactive for three years before he lost to Tunney and was determined to be in shape for the rematch. He knocked out future champion Jack Sharkey in seven rounds, just two months before the September 22, 1927, rematch with Tunney. (Pugilistica.com collection.)

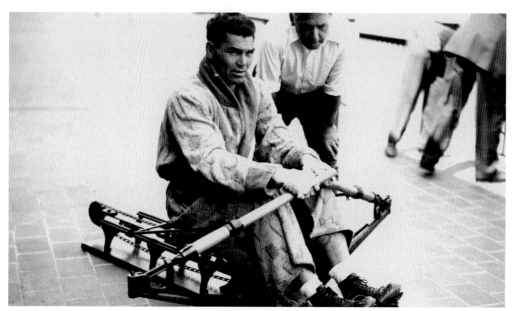

Dempsey works out on a rowing machine while preparing for his second bout with Tunney. His bout with Jack Sharkey was an elimination bout to determine a challenger for Tunney. Dempsey appeared to be behind in points when, in the seventh round, Sharkey turned to complain to the referee about low blows. Dempsey took advantage of the moment and landed a left hook, knocking Sharkey out cold. (Pugilistica.com collection.)

Dempsey scored 49 knockouts, third most among heavyweight champions. He punched so hard that many accused him of packing his fist with plaster of paris. Dempsey was one of the most popular athletes of all time. His fight with Gene Tunney attracted 100,000 fans, including Charlie Chaplin, Damon Runyon, and Princess Xenia of Greece. (Pugilistica.com collection.)

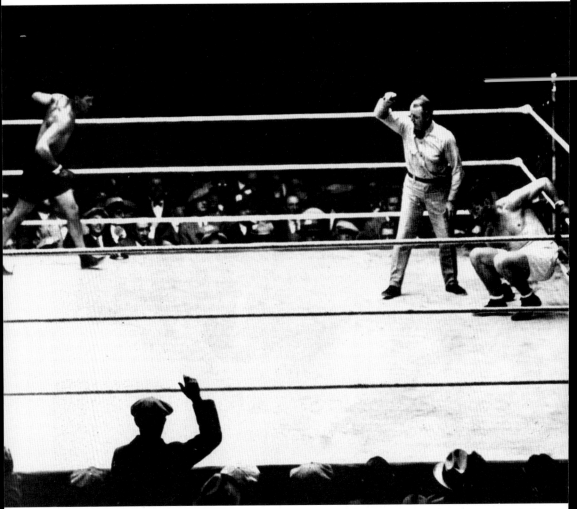

The rematch between Gene Tunney and Jack Dempsey became known as the battle of the "Long Count." Dempsey dropped Tunney in Round 7 and refused to follow the rules, which stated that the fighter scoring a knockdown must go to the furthest neutral corner. Referee Dave Barry stopped his count until Dempsey obeyed the rules. By the time he picked up his count, several seconds had elapsed, and although Tunney rose at the official count of nine, he had been down a total of 14 seconds. While many people feel that Tunney should have been counted out, a review of the films shows that he wisely remained on the canvas until the last possible second and that he may have been able to rise inside of the 10 count. While that will forever be debated, what is certain is that when Tunney got up, he did not give Dempsey another chance. He stayed away the rest of the round and even came back to floor Dempsey in Round 8. The fight was not close, and Tunney won a decision by a comfortable margin. (Pugilistica.com collection.)

Dempsey was labeled a "slacker" early in his career since he did not serve in the military during World War I. He eventually produced some evidence that he did try to enlist but was rejected. He volunteered during World War II and served in the Coast Guard. In 1945, he insisted on going into battle in Japan. (Pugilistica.com collection.)

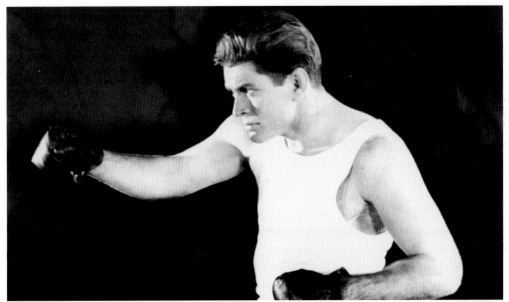

New York's first heavyweight champion was Gene Tunney. Known as "the Fighting Marine," Tunney defeated living legend Jack Dempsey to win the heavyweight championship in 1926. He lost only one fight in his 83-bout career. This flawless boxer was also American light heavyweight champion from 1922 to 1924. Tunney served in Europe during World War I, where he won the Allied Forces boxing championship. (Pugilistica.com collection.)

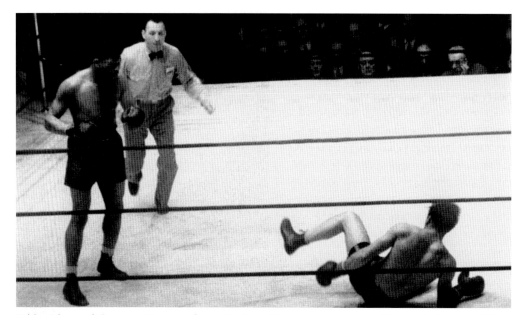

Eddie Blunt of Corona, Queens, floors Nathan Mann en route to a 10-round decision. Blunt was trained by Whitey Bimstein and fought from 1935 until 1948, totaling more than 70 bouts. Nicknamed "the Dark Spoiler," Blunt also scored wins over Buddy Baer, Lee Savold, Tony Musto, Abe Simon, Willie Reddish, Al Gainer, Jorge Brescia, and Leroy Haynes. He also competed against Tony Galento, Melio Bettina, and Tiger Jack Fox. (Pugilistica.com collection.)

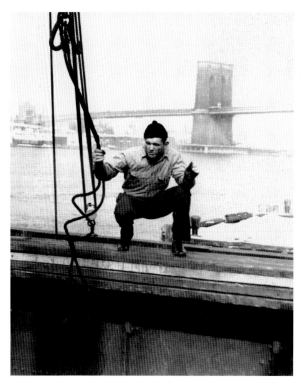

This is future heavyweight champion Jim Braddock working on the New York docks. The photograph was taken in 1933, and the Brooklyn Bridge is visible in the background. Braddock's incredible life story was recently turned into a major Hollywood motion picture. He was called the "Cinderella Man" because of his rags-to-riches life. (Pugilistica.com collection.)

Braddock defeated Max Baer to become heavyweight champion on June 13, 1935. The dangerous Baer was a hard puncher, but Braddock did not give him a chance to score with his big right. Utilizing speed combined with clever footwork, Braddock outclassed Baer and culminated one of the greatest comebacks. Just a few years before, out of work and injured, he was forced to accept government relief. Once he became champion, he repaid the government. Braddock was born in New York City on June 7, 1905. He later moved across the Hudson River to New Jersey, where he turned pro in 1926. He started out as a light heavyweight and became a contender following impressive wins over Jim Slattery, Pete Latzo, and Tuffy Griffiths. He challenged the clever Tommy Loughran for the title, losing a decision in 1929 at Yankee Stadium. (Pugilistica.com collection.)

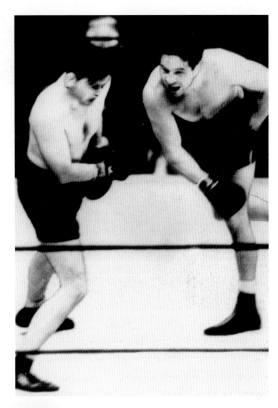

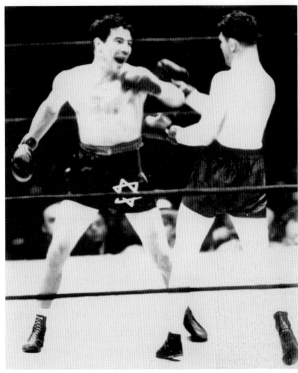

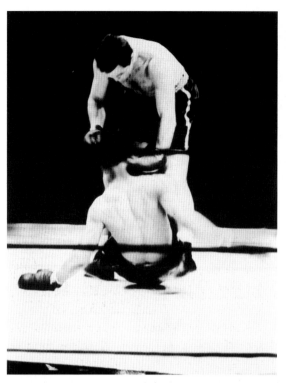

Jim Braddock made his first defense against Joe Louis on June 22, 1937. They fought in front of 45,500 fans at Chicago's Comiskey Park. Both fighters weighed in at 197 pounds. Louis came in with a 34-1 record, which included knockouts over three former champions. Braddock had been idle for two years since beating Max Baer for the title. Braddock floored Louis, left photograph, in the first round with a left hook. In the eighth round, Louis cut Braddock under the left eye and knocked him out for the count with a right cross at 1 minute and 10 seconds. Braddock and his manager worked out a deal that entitled them to 10 percent of Joe Louis's earnings as champion. Louis would be champion for 12 years and went on to make 25 defenses. (Pugilistica.com collection.)

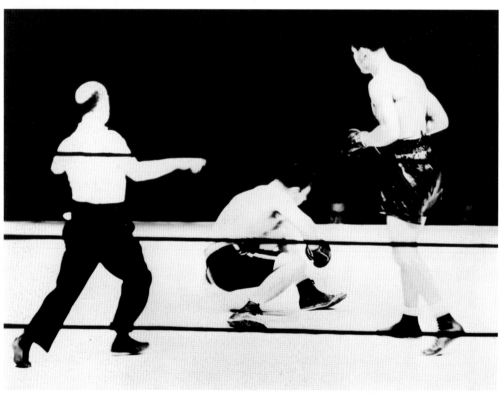

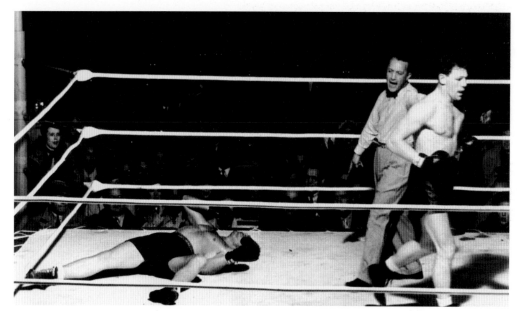

Bob Pastor drops Bob Nestell in their May 28, 1937, match in Los Angeles. The boxers exchanged knockdowns in the first round, and Pastor floored Nestell again in the third on the way to a decision victory. Pastor was a popular attraction throughout the country and headlined bouts in Los Angeles, New York, Boston, and Chicago. (Pugilistica.com collection.)

In 1937, Pastor frustrated Joe Louis with his movement, lasting all 10 rounds. It was the first time Louis went the distance in a New York ring. Pastor weighed only 179 pounds for that match, and the decision for Louis was booed by the crowd of 18,864. Pastor, a fullback for New York University, bloodied Louis's nose in the fifth round and battered his ribs throughout the fight. (Pugilistica.com collection.)

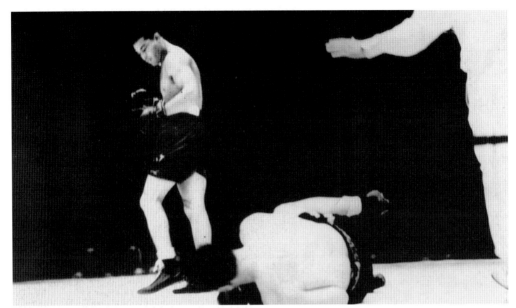

Joe Louis proved too much for Bob Pastor in their September 20, 1939, title match at Briggs Stadium in Detroit. Louis floored Pastor four times in Round 1 and once again in Round 2. The crafty Pastor managed to last until Round 11. It was the first time in 46 bouts that Pastor failed to go the distance. (Pugilistica.com collection.)

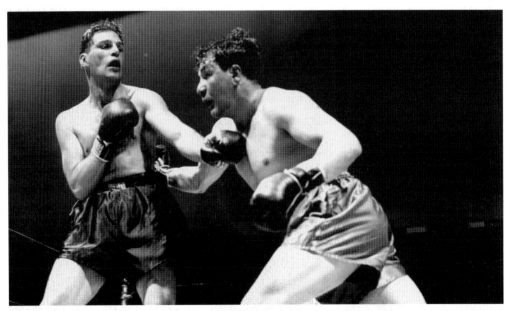

Tami Mauriello of the Bronx scores with a right to the body of Lee Oma on March 23, 1945. Mauriello won by decision after 10 rounds. Mauriello took two out of three from Oma. Mauriello challenged Joe Louis for the championship in an explosive one-round fight that saw Mauriello jump all over Louis and drive him back to the ropes before being knocked out. (Pugilistica.com collection.)

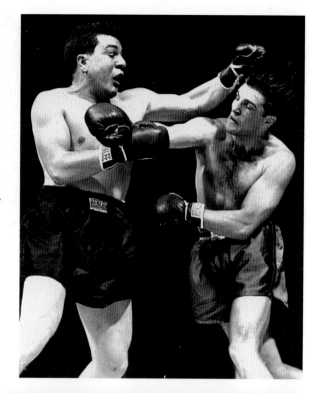

Mauriello scores with a left against Oma during their 1944 bout. They fought twice that year, with Mauriello winning the first and Oma the second. Mauriello got into boxing after following the career of Carl Duane. He debuted in 1939 as a welterweight and fought all the way up to heavyweight. He twice challenged Gus Lesnevich for the light heavyweight title, losing both by decision. (Pugilistica.com collection.)

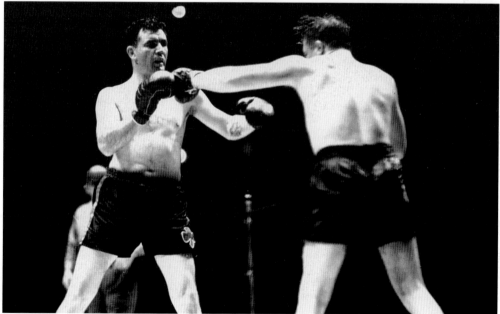

After all that he had gone through, Jim Braddock did not want to retire on a losing note. After losing his title to Joe Louis, he took on the tough Tommy Farr. Farr was also coming off a decision loss to Louis in a title fight. Braddock came from behind to beat Farr on points. (Pugilistica.com collection.)

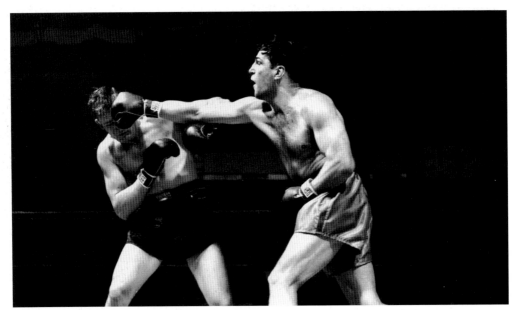

Lee Oma lands a right to the head of Joe Baksi. Oma won by decision after 10 rounds. Baksi was born in Pennsylvania and fought out of New York. Trained by Whitey Bimstein, Baksi beat Gus Dorazio, Tami Mauriello, Lee Savold, Buddy Knox, Gunnar Barlund, Lou Nova, Freddie Mills, and Freddie Schott. (Pugilistica.com collection.)

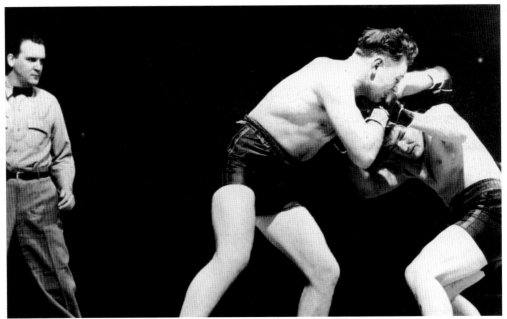

Baksi misses with a jab against Lee Savold in their 1944 bout at Madison Square Garden. They fought twice that year, each winning a 10-round decision. Baksi was the leading contender after upsetting Bruce Woodcock in 1947. He was next in line to challenge Joe Louis but lost a decision to the unheralded Olle Tandberg while vacationing in Sweden. (Pugilistica.com collection.)

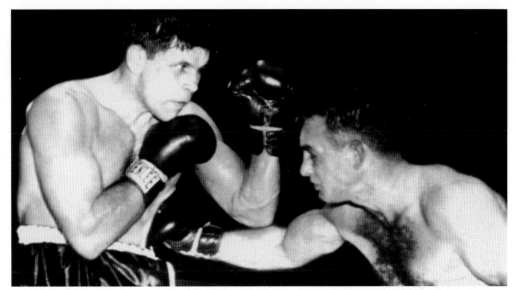

Charley Norkus's persistent body attack paid off as he managed a 10-round decision over the talented Roland LaStarza. The bout took place on December 1, 1954, in Cleveland. LaStarza, of the Bronx, was thought a future champion when he came up in 1947. He was 36-0 when he took on 25-0 Rocky Marciano in 1950. Marciano won a very close decision. They fought again in 1953 for the championship. Marciano won by an 11th-round knockout in a grueling affair. LaStarza, who graduated from City College of New York, appeared in several movies after his career. Norkus was from nearby Bellerose in Queens. He boxed against Ezzard Charles, Archie Moore, Willie Pastrano, Roy Harris, and Tommy Jackson. He beat Danny Nardico, Cesar Brion, and George Washington. Washington himself went on to great success as a trainer of Riddick Bowe and Mark Breland. (Pugilistica.com collection.)

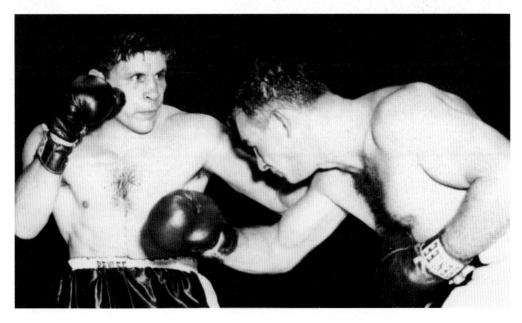

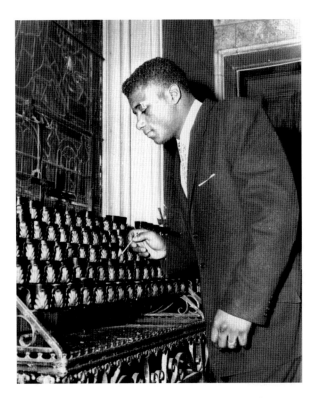

Floyd Patterson lights a candle at Brooklyn's Holy Rosary Church, located on Chauncey Street, in Bedford Stuyvesant. Floyd later moved to New Paltz and trained boxers, including his adopted son, Tracy Harris Patterson, who became champion. Late in his career, Tracy was criticized by the media for splitting with Floyd. Tracy never once spoke badly about Floyd, and shortly after, news spread that Floyd was suffering from Alzheimer's disease. (Pugilistica.com collection.)

Floyd Patterson and Ingemar Johansson engaged in one of the most exciting trilogies the sport has known. Johansson shocked with a third-round knockout their first fight. A year later, on June 20, 1960, Floyd regained the title with a knockout in five rounds, becoming the first heavyweight to regain the title. They became close friends and visited each other often. (Pugilistica.com collection.)

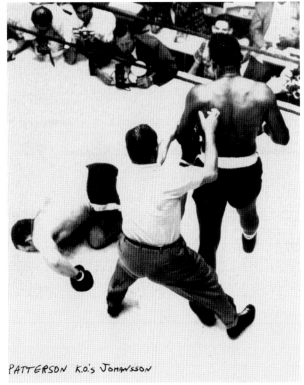

PATTERSON K.O.'s JOHANSSON

Muhammad Ali and Floyd Patterson fought twice, with Ali winning each time. Ali successfully defended his title on November 22, 1965, with a one-sided 12-round stoppage. Patterson aggravated a disc in his back early in the fight, and it restricted his movement. Earlier that year he beat Canadian strongman George Chuvalo despite fighting with a separated bone in his hand. (Pugilistica.com collection.)

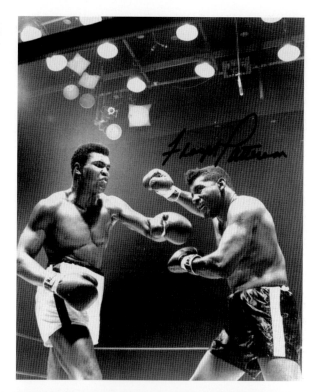

Brooklyn's "Iron" Mike Tyson battles the Bronx's Mitch "Blood" Green in a Madison Square Garden main event in 1986. Green lasted the distance, which in those days, against Tyson, was as good as a win. They fought again some two years later at a Harlem nightspot. Their street fight received more headlines than their boxing match. Tyson reportedly got the better of that match as well.

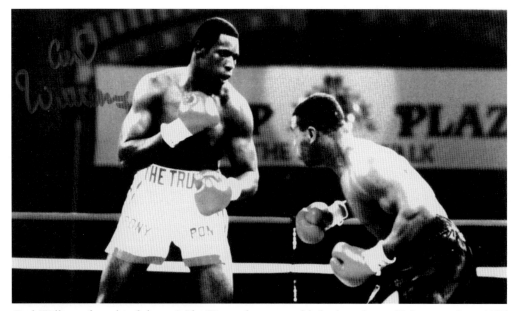

Carl Williams lost this fight to Mike Tyson, but many felt he beat Larry Holmes in their 1985 title fight. Tyson is about to land the left hook that dropped Williams. Williams beat the count, but the referee stopped the fight. Williams may or may not have been able to continue, but such was Tyson's reputation in those days that referees did not take any chances.

Tyson broke onto the scene scoring knockouts every two weeks. He struck fear into many of his foes. An expert boxing historian, Tyson once said that he wanted to be remembered as someone who would have given anyone a tough fight. Things soon took a turn for the worst. The deaths of his trainers, Cus D'Amato and Jim Jacobs, were followed by losses, arrests, and suspensions.

2

THE LIGHT HEAVYWEIGHTS

Known in some parts of the world as cruiserweights, the 175-pound class was created in 1903. James Coffroth claims to have created the division, but most people give that credit to Chicago boxing manager and newspaper writer Lou Houseman, who is said to have created the division when his boxer Jack Root outgrew the middleweight class. Root became the first of all light heavyweight champions, a group which includes seven New Yorkers. Paul Berlenbach was the first to do so, although Gene Tunney had recognition as American champion. Tunney is also credited as being the first American boxer to fly from his training camp to a match. He flew from Stroudsburg, Pennsylvania, to Philadelphia on September 23, 1926, to weigh in for his fight against Jack Dempsey.

Renowned referee John Gaddi pulled off one of the most impressive feats in boxing during the 1916 National AAU tournament. Gaddi won the middleweight, light heavyweight, and heavyweight championships in one night. Less than two years later he was injured 17 times while fighting during the Meuse-Argonne Offensive in World War I. Brooklyn's Joe Jakes set a local record for the fastest fight, knocking out Al Foreman in 11 seconds. He himself was stopped in just 20 seconds in his next fight.

Doug Jones was a top-rated contender who challenged Harold Johnson for the title. He scored wins over Bob Foster and Bobo Olson. He later moved up to heavyweight and challenged for the title. He beat Zora Foley and Billy Daniels. His loss to Muhammad Ali was close enough to have been scored a win. He also fought Joe Frazier.

Jackie Tonawanda made history by becoming the first female to box at Madison Square Garden. She scored a knockout over a male kickboxer in a 1975 exhibition. Later, along with Cathy "Cat" Davis and Lady Tyger Trimiar, she became the first female boxer licensed in the state. Other women boxers from the city to make a mark in the sport include bantamweight Sandy Perez and Diane Clark, who was recognized as light heavyweight champion by the Women's Boxing Federation in 1980, quite possibly the first official female champion from New York.

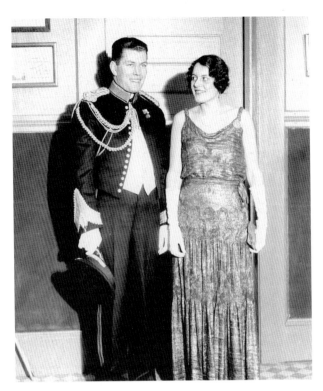

Gene Tunney and his wife pose at the 1928 Governor's Inauguration Ball in Connecticut. Gene's wife, Polly Lauder, was a wealthy heiress and a niece of Andrew Carnegie. Gene kept his promise to her and never fought after they married. Their son, John V. Tunney, was elected to the U.S. Senate in 1970, representing the state of California. (Pugilistica.com collection.)

Mike McTigue was born in Ireland and lived in New York. He took the light heavyweight title from Battling Siki via a 20-round decision. His complete record may never be known. He started boxing around 1909 and may have amassed a total of 200 bouts. He boxed Harry Greb, Jeff Smith, Tommy Loughran, Young Stribling, Tiger Flowers, Paul Berlenbach, and Jack Sharkey. (Pugilistica.com collection.)

McTigue dethrones Battling Siki of Senegal on St. Patrick's day, 1923, in Dublin, Ireland. Siki was adopted by a French woman and served as her houseboy. As a teenager, he joined the French Army during World War I, earning the Croix De Guerre. Siki moved to New York and was often in trouble with the law. He was shot to death at age 28, allegedly by a cop. (Pugilistica.com collection.)

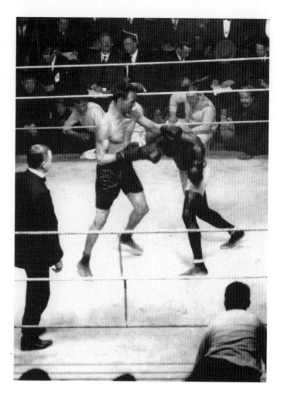

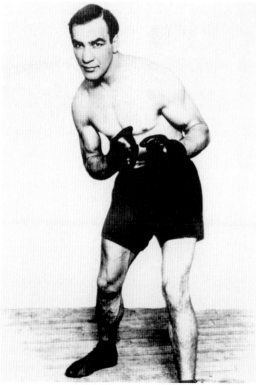

Paul Berlenbach was one of the hardest punchers in history. His first 20 victories came via the knockout route. He was champion from 1925 until 1926 and made three successful defenses. He beat Battling Siki, Jimmy Slattery, Young Stribling, Jack Delaney, and Mike McTigue. He also fought Mickey Walker, Johnny Risko, and Augie Ratner. (Pugilistica.com collection.)

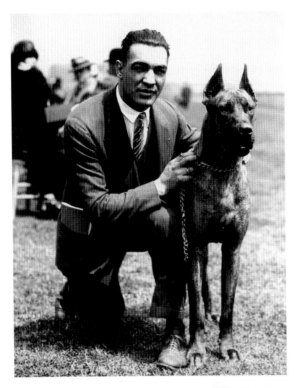

Paul Berlenbach poses with his pet Great Dane in this 1927 photograph. The "Astoria Assassin" won the championship from Mike McTigue in 1925. A champion wrestler who turned to boxing, Berlenbach possessed one of the most potent punches ever. He was a huge attraction, and his matches against rival Jack Delaney packed baseball stadiums. (Pugilistica.com collection.)

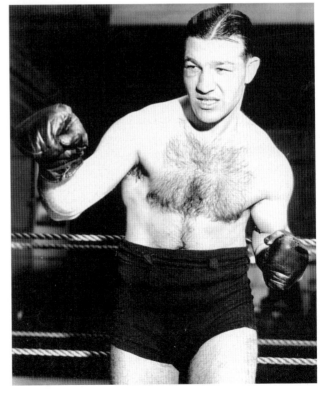

Bob Olin became world champion after outscoring "Slapsie" Maxie Rosenbloom over 15 rounds on November 16, 1934. Leading up to that fight, Olin scored victories over Al Gainer, heavyweight Charley Massera, and former champion Bob Goodwin (in a one-round knockout). He lost the title the following year to the vastly underrated John Henry Lewis. Olin often took on heavyweights like Tommy Farr, Johnny Risko, Abe Feldman, and Buddy Knox. (Pugilistica.com collection.)

"Slapsie" Maxie Rosenbloom engaged in 299 fights from 1923 until 1939. He scored an amazing 223 wins over the likes of Dave Shade, Tiger Jack Fox, Mickey Walker, Bob Goodwin, John Henry Lewis, Lou Nova, and Lee Ramage. He was light heavyweight champion from 1930 until 1934. Rosenbloom was a defensive master who was stopped only twice. After boxing, Rosenbloom enjoyed a successful career in acting, appearing in over 60 films. (Pugilistica.com collection.)

Yale Okun was a fast, clever boxer who managed wins over Jim Braddock and Tony Marullo. He also fought a draw against Rosenbloom. Yale's safety-first style was not crowd pleasing, but he was still popular among fans. He also fought Tommy Loughran, John Henry Lewis, Lee Ramage, and Leo Lomski. (Pugilistica.com collection.)

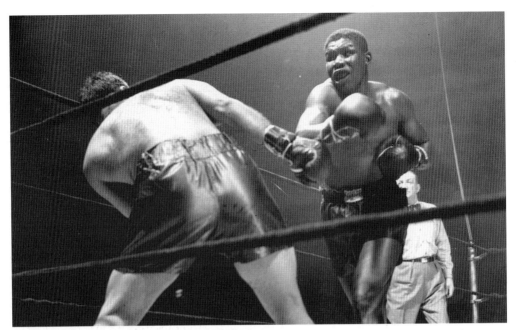

Melio Bettina slips the dangerous right cross of Jimmy Bivins. He split three fights with Bivins. Bettina was born in Bridgeport, Connecticut, and started boxing in New York in 1934. He finished with 100 fights and won the vacant title in 1939. He lost it later that year to Billy Conn. He also beat Tiger Jack Fox, Fred Apostoli, Eddie Blunt, and Bob Goodwin. (Pugilistica.com collection.)

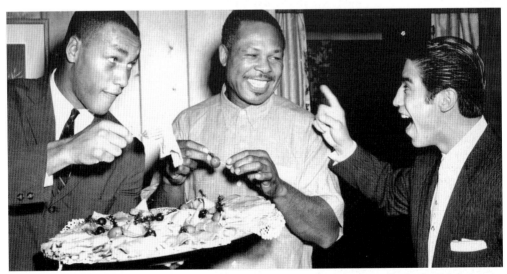

Tony Anthony and Archie Moore share some appetizers with featherweight knockout artist Ricardo Moreno before their September 20, 1957, title match. Moore defended his championship with a seventh-round stoppage. Anthony started out as a middleweight in 1952 and became ranked as a light heavyweight a few years later. The Manhattan native had more than 50 fights in his eight-year career, including a win over Yvon Durelle. (Pugilistica.com collection.)

Floyd Patterson won a gold medal at the 1952 Olympics as a middleweight. He turned pro later that year and became ranked as a light heavyweight. After Rocky Marciano retired, Patterson moved up to heavyweight and beat crosstown rival Tommy Jackson over 12 rounds. He became the youngest to win the heavyweight title in his next fight, knocking out Archie Moore in five rounds. He was 21 years old. (Pugilistica.com collection.)

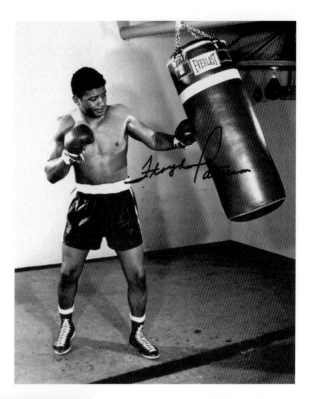

Jose Chegui Torres was born in Puerto Rico and fought out of Brooklyn. A silver medalist at the 1956 Olympics, he went on to become a contender in the middleweight division and a champion at 175 pounds. Torres's career was cut short due to pancreatic problems. He later became a best-selling author and was athletic commissioner of New York. He was also president of the World Boxing Organization (WBO).

Randy Stevens came to New York from the Virgin Islands. Stevens traveled the world during his career. He boxed in Germany, Puerto Rico, Venezuela, Italy, England, and New Zealand. He fought Frankie DePaula, Bobby Cassidy, Hal Carroll, Georgie Johnson, and Vicente Rondon. He also boxed heavyweights like Lorenzo Zanon and Jose Luis Garcia. He stopped fighting after an eye injury and currently trains fighters at the Starrett City Boxing Club. (Pugilistica.com collection.)

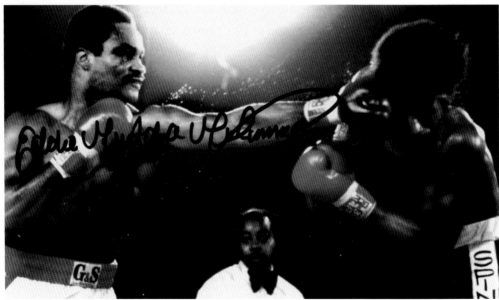

Eddie Mustafa Muhammad lands a jab on Michael Spinks. He lost his World Boxing Asociation (WBA) title to Spinks after 15 rounds. Originally known as Eddie "the Flame" Gregory, the Brooklyn native was a fine boxer with excellent power. He started out at middleweight and fought all the way up to heavyweight. He beat Marvin Johnson, Matthew Saad Muhammad, and Jesse Burnett. Eddie, a top trainer, helped form a boxing union.

The Middleweights

With champions dating as far back as the 1860s, the middleweight division is one of the oldest divisions in the sport. The maximum weight allowed is 160 pounds. Jack Dempsey, known as "the Nonpareil," was the first from New York to win the championship. His career overlapped the bare-knuckle and gloved eras. A total of 14 boxers from New York won the championship as of 1990. The junior middleweight division was formed in 1962 with Emile Griffith being the division's first champion. Four others from the city have also won recognition as junior middleweight champions. The junior middleweight division has a weight limit of 154 pounds.

Among the earliest of middleweight stars was Al McCoy, who shocked George Chip with a first-round knockout to win the title. McCoy hailed from Brooklyn and battled all of the top fighters of his day. Dave Rosenberg was a national amateur champion at welterweight and went on to win the middleweight title as a pro in 1922. Larry Estridge won the colored championship in 1924. A native of the West Indies, he came to Harlem and established himself as one of the best. He was avoided heavily during his career and was not given any breaks because of his skin color. Most of the big fights he took were against larger men or at the end of his career, long after his prime. Augie Ratner took on absolutely everyone during his career. He boxed eight world champions and had more than 100 fights.

Paddy Young, Walter Cartier, Jimmy Flood, and Harold Green were all attractions during the 1940s. Young, of Greenwich Village, beat Ernie Durando, Charlie Fusari, and Harold Green. Green defeated Durando, Rocky Graziano two times, and Fritzie Zivic. Jose Basora held a prime Sugar Ray to a draw and beat Jake LaMotta. Herbie Kronowitz and Artie Levine were top-notch operators as well, with Levine dropping Sugar Ray Robinson and coming within a second of knocking him out. More recent years saw Jose Gonzalez engage in some bruising encounters with Dick Tiger, Rubin "Hurricane" Carter, Jose Torres, and Mustafa Hamsho, who was the second-best middleweight for many years behind Marvin Hagler. Hamsho beat Wilfred Benitez, Alan Minter, and Bobby Czyz.

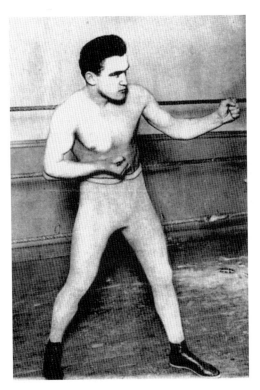

Jeff Smith was called "the Globetrotter" and is said to have logged more miles traveled than any boxer in his day. He sailed around the world twice during his 185-fight career. He boxed from 1910 until 1927 and took on Harry Greb, Willie Lewis, Mike Gibbons, and Les Darcy. He boxed in Australia, France, England, Canada, and Mexico. Smith was champion from 1914 until 1915. (Pugilistica.com collection.)

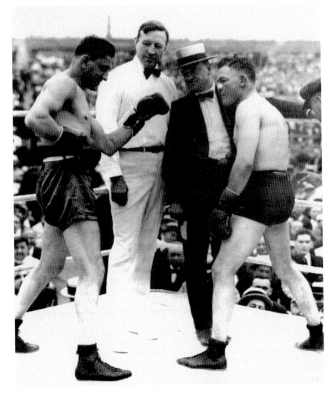

Johnny Wilson squares off with William Bryan Downey before their July 27, 1921, bout in Cleveland. Wilson won by disqualification after seven rounds. Wilson was champion from 1920 until 1923, losing the title to Harry Greb. Wilson, a southpaw, fought over 125 fights from 1911 until 1926. He also fought Leo Houck, Augie Ratner, Mike O'Dowd, Tommy Loughran, Jock Malone, Tiger Flowers, and Maxie Rosenbloom. (Pugilistica.com collection.)

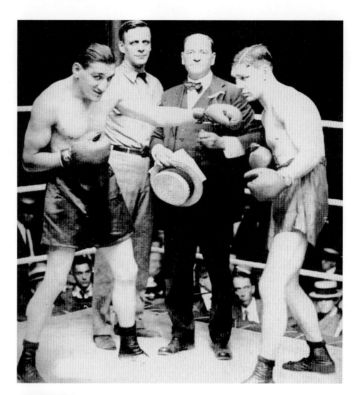

Johnny Wilson poses with Harry Greb at the start of their August 31, 1923, fight. Wilson was rumored to be mob connected. He was friends with Al Capone and Frank Costello. Greb won a decision but without his usual fouling. Some say he was afraid of being disqualified, while others said he was told that he better behave. Wilson later operated nightclubs in New York and Boston, including the Silver Slipper. (Pugilistica.com collection.)

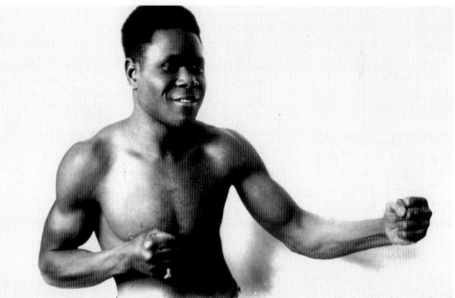

Sam King was one of the many boxers who fought at the New York armories during the 1920s. Many of the fighters were servicemen who boxed while stationed in the city. Others were local fighters who took advantage of the amount of shows put on by the armories. In fact, the New York State National Guard recognized its own champions and awarded championship belts. (Pugilistica.com collection.)

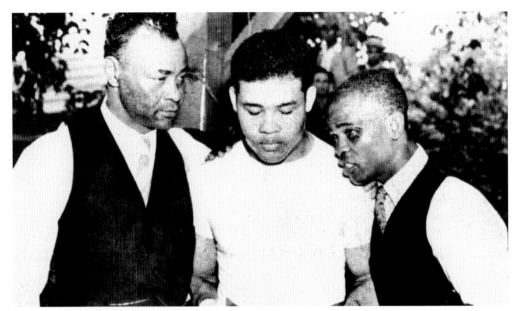

Joe Louis is flanked by Harry Wills (left) and "Panama" Joe Gans. Gans was born in Barbados and moved to Panama when he was young. He quickly became the best boxer in Panama. In 1918, he came to New York and established himself as one of the best. He won the colored middleweight championship and defeated Jack Blackburn and Tiger Flowers. He was never knocked out in more than 150 fights. (Pugilistica.com collection.)

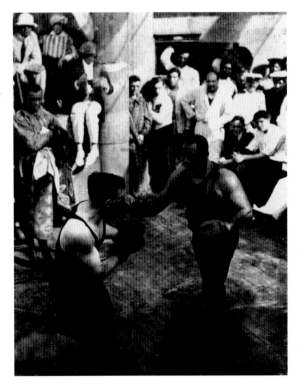

Albert Badoud of France spars with Sam Langford aboard a ship. Badoud stayed in New York for two years and took on the likes of Augie Ratner and Jack Britton. Langford boxed from lightweight all the way up to heavyweight. Harry Wills can be seen off to the left. Sam McVea is also present, appearing on the right. (Pugilistica.com collection.)

George Levine was one of the few white fighters willing to cross the racial barrier. He beat Gans and fought a draw with Canada Lee. He lost by disqualification to Pete Latzo in 1926 in his only shot at the world championship. He boxed more than 100 times and shared the ring with champions Tommy Freeman and Joe and Vince Dundee. He also fought Dave Shade. (Pugilistica.com collection.)

Young Terry, Benny Leonard, Tony Herrera, and Jimmy McLarnin pose at a training camp. The following year Leonard came out of retirement and lost in six rounds to McLarnin. McLarnin went on to become champion and was part of a string of 11 consecutive bouts where the champion was dethroned. The streak was eventually stopped by Barney Ross. (Pugilistica.com collection.)

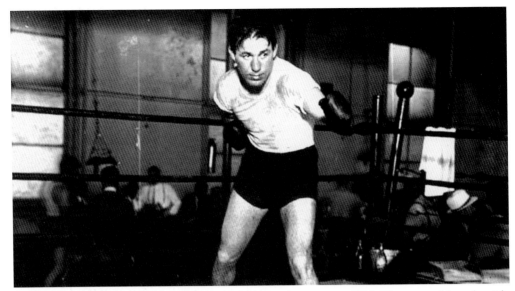

Solly Krieger was a hard-hitting battler who became champion in 1938. He won and lost the title to Al Hostak. Krieger, who lived in Brooklyn, also beat Billy Conn, Allen Matthews, Young Terry, and Swede Berglund. Krieger, who possessed a wicked body attack, fought a memorable pair of bouts with fellow New Yorker Walter Woods, including a thrilling come-from-behind knockout.

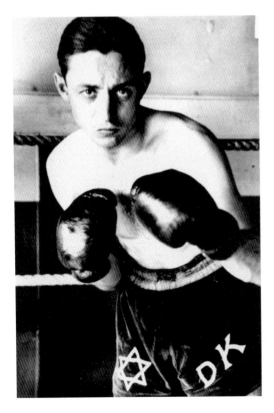

Bronx southpaw Danny Kapilow was a durable battler who was stopped only once in close to 70 fights. He held the much bigger Rocky Graziano to a draw and beat Wesley Mouzon and Freddie Archer. He also beat Gene Burton, drew with Willie Joyce, and lost an unpopular decision to Sammy Angott. Kapilow also met Johnny Bratton, Beau Jack, and Jimmy Doyle. (Pugilistica.com collection.)

Atilio Sabatino came to New York in 1930 as Puerto Rican welterweight champion. He held wins over outstanding Puerto Rican Angel Cliville and Cuban star Relampago Saguero, but had trouble getting fights. Sabatino was one of the many good boxers who were avoided because of their skin color. He wrapped up his career in Australia and defeated greats such as Ron Richards and Fred Henneberry. (Pugilistica.com collection.)

Milton Krompier fought out of the Bronx. He weighed between 130 and 150 pounds throughout his career. He boxed during the 1930s and beat Jack Terranova and Johnny Fitzpatrick. His brother Marty was known as the right-hand man of gangster Dutch Schultz. Marty Krompier was one of Murder Inc.'s targets on October 23, 1935, when they attempted to rub out the Dutch clan. Milton donated blood to save his brother's life. Milton was unbeaten in about 20 fights. (Pugilistica.com collection.)

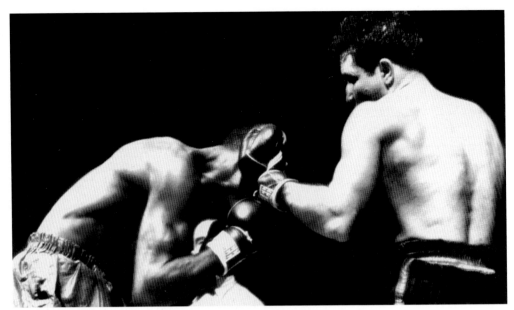

Jake LaMotta scores with a left to the side of Tommy Bell's head. LaMotta was often criticized for taking on welterweights like Bell, Fritzie Zivic, Tony Janiro, and Ray Robinson. LaMotta, of course, took on many middleweights as well and claimed to take on smaller fighters in order to stay active. He beat Bell three times, although one of the bouts is considered to be among the worst decisions ever. (Pugilistica.com collection.)

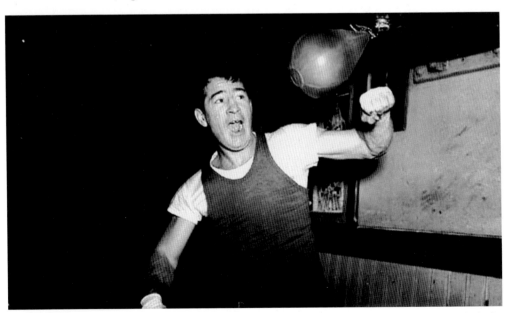

Rocky Graziano made headlines even when not fighting. He was suspended in New York for failing to report a bribe. The fight never came off so Graziano never felt the need to report it. He was also discharged from the army for punching an officer. He once joked that he dropped out of grade school because of pneumonia. He never had pneumonia, he just could not spell it.

LaMotta poses proudly with his championship belt. It did not come easily for LaMotta, who spent several years as the leading contender before getting a shot at the title. LaMotta refused to deal with all of the unsavory characters who controlled much of boxing back then. They in turn shut him out of the title picture until LaMotta finally gave in, agreeing to throw a fight against light heavyweight Billy Fox. LaMotta lost after four rounds but did not go down, keeping intact his record of never touching the canvas. He kept that record until his 102nd bout in 1952. Danny Nardico became the first and only boxer to floor LaMotta, doing so with a vicious right hand in the seventh round. LaMotta finished with 83 wins in 106 bouts. He took on boxers of all sizes and colors.

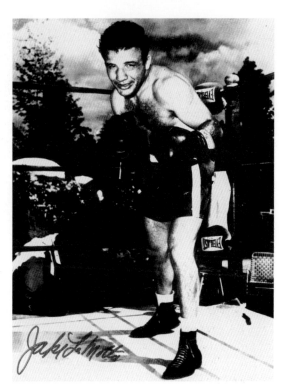

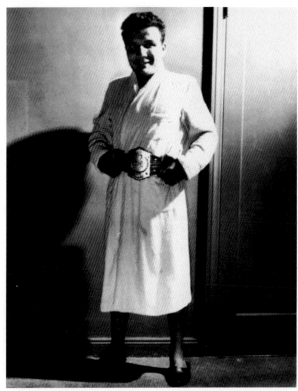

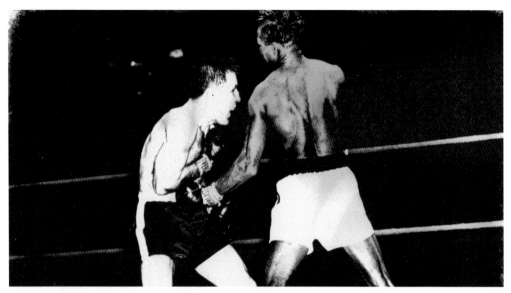

Sugar Ray Robinson became middleweight champion on February 14, 1951, stopping Jake LaMotta in Chicago. The fight turned one sided after the seventh round, with Robinson stopping a bloodied LaMotta in the 13th round. Robinson delivered a frightening beating, and it led to the fight being dubbed "the St. Valentine's Day Massacre" after the 1929 Chicago gang shootout between members of the Al Capone and Bugs Moran crime families.

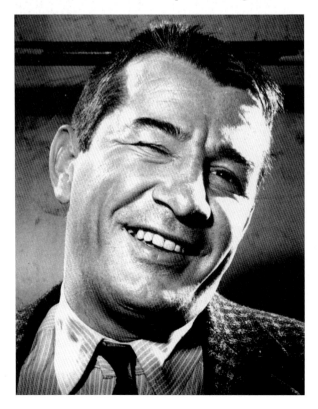

After retiring, Rocky Graziano made several appearances on television. He hosted his own series with comedian Henny Youngman and appeared in television commercials many years after his retirement. His autobiography, *Somebody Up There Likes Me*, was a best seller and was later turned into a movie where Graziano was portrayed by Paul Newman. He was champion from 1947 until 1948.

Jimmy Herring appeared on television more than 40 times in the New York City area. He was a popular fighter who attracted scores of high school students, both male and female, to his fights. Herring, from Ozone Park in Queens, beat Sal DiMartino, Jimmy Flood, Artie Diamond, Sonny Horne, and Ralph "Tiger" Jones.

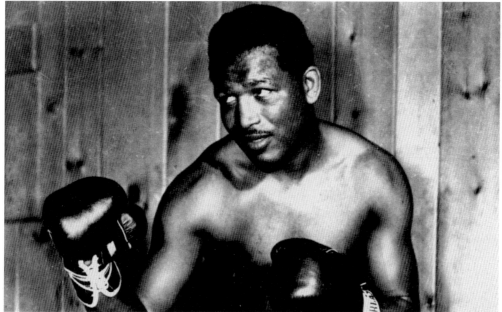

If ever there was a perfect boxer, Sugar Ray Robinson would be him. Born Walker Smith Jr. in 1921, Robinson was unbeaten in over 100 fights as a welterweight and lightweight. He was great at boxing and slugging. He possessed one-punch knockout power in both hands and could knock an opponent out while going backwards. He is almost the unanimous choice among boxing experts as the best boxer ever. (Pugilistica.com collection.)

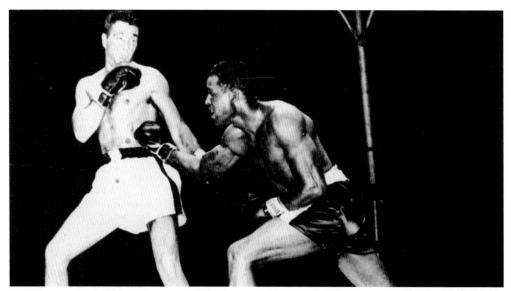

Ray Robinson lands a right to Joey Maxim's side during his challenge for the light heavyweight title. Robinson started out at a lightweight and won titles at welterweight and middleweight. Although he came close, light heavyweight was a bit too much for him. He was outboxing Maxim, but then succumbed to the 104-degree heat. He did not come out for the 14th round, and Maxim kept his title. (Pugilistica.com collection.)

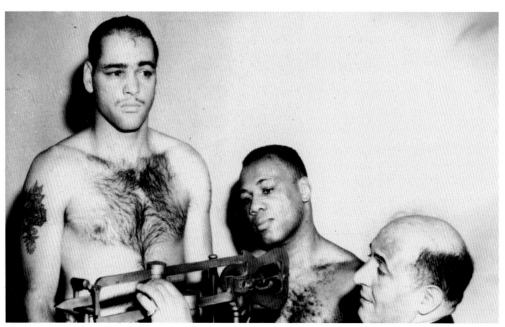

Ralph "Tiger" Jones checks Carl "Bobo" Olson's weight as they prepare for their 1955 bout in Chicago. Olson was the reigning middleweight champion and won a 10-round decision. Although the title was not on the line for this match, it probably should have been since Jones was coming off his upset victory over Robinson. (Pugilistica.com collection.)

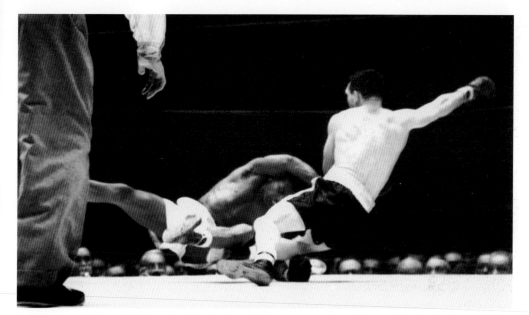

Robinson and Gene Fullmer hit the deck in their rough-and-tumble middleweight bouts. They fought four times, with Fullmer winning the first and last matches. The third match was a draw, and Robinson won their second bout with a left hook that made it into the encyclopedia as an example of a perfect punch. (Pugilistica.com collection.)

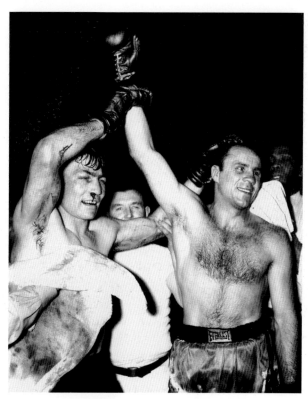

Perennial contender Steve Belloise has his hand raised by French champion Jean Stock. Belloise traveled to Paris, France, to take on the highly regarded Stock. He scored two knockdowns en route to winning via an eight-round knockout. Belloise was the first to beat the superb Frenchman Robert Villemain. He failed to pull off a hat trick, losing to France's other top contender, Laurent Dauthille. (Pugilistica.com collection.)

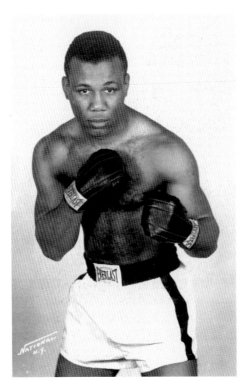

Ralph "Tiger" Jones was one of the most exciting boxers of the 1950s. A popular and regular performer, he was one of the first stars of television. The Brooklyn resident was an aggressive battler who defeated Sugar Ray Robinson, Kid Gavilan, and Joey Giardello. His last-round, come-from-behind knockout of Bobby Dykes in 1954 is among the most memorable bouts of the 1950s. (Pugilistica.com collection.)

Steve Belloise of the Bronx was a leading contender for the entire 1940s. He beat Ceferino Garcia on September 12, 1940, and remained near the top until his last fight. He had more than 110 contests and won about 95 of them. He beat Coley Welch, Georgie Abrams, Anton Christiforidis, Izzy Jannazzo, and Anton Raadik. (Pugilistica.com collection.)

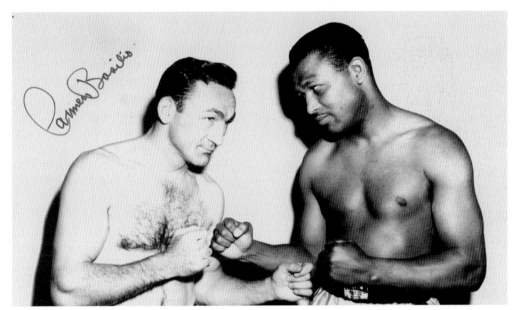

Carmen Basilio and Ray Robinson square off before their middleweight title bout. Basilio won the first match, held on September 23, 1957. Robinson won the rematch the following year. Basilio was from Canastota, New York, and was also welterweight champion. Both fights were among the most exciting of all time. (Pugilistica.com collection.)

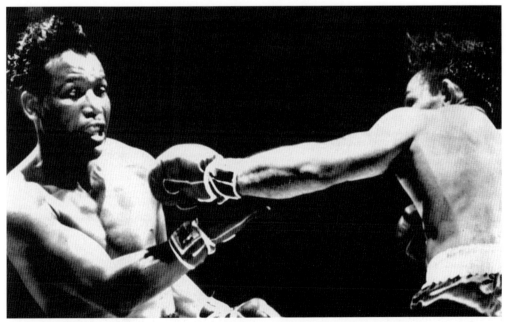

Robinson takes a left from Basilio. They split their two bouts, and Robinson priced himself out of a third match. Robinson's most famous rivalry was the six-fight affair he had with Jake LaMotta. LaMotta was the first to beat Robinson. He did not lose again until his 133rd fight. Robinson later served as LaMotta's best man at his wedding. (Pugilistica.com collection.)

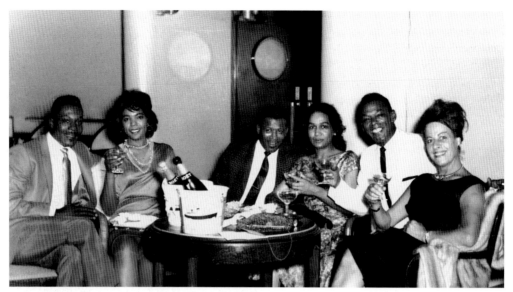

Ray Robinson and friends are on board a cruise ship to Europe in 1962. Robinson was heading to England to fight Terry Downes and later made stops in Austria and France. Robinson made several trips abroad and fought in France, Belgium, Germany, Switzerland, Italy, and England while champion. His European tour was well documented, and he took with him everyone who could fit, even his personal barber. (Pugilistica.com collection.)

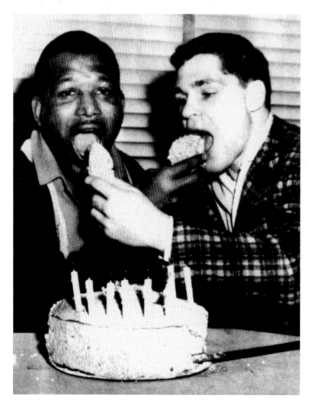

Robinson and Denny Moyer share a piece of birthday cake celebrating Robinson's 21st anniversary in boxing. They split a pair of bouts. Robinson was a flashy boxer up until his final fights. Robinson fought all of the big names of his era. He is sometimes criticized by some for not fighting Charley Burley, but Burley, great as he was, just was not a big attraction. (Pugilistica.com collection.)

Despite getting this prefight rub down, Robinson's legs could not carry him to victory over Terry Downes. Robinson fought well past his prime. His career lasted from 1940 until 1965. Despite being just a shell of his former self, he was still competitive against a decent level of opposition. He took on Ralph Dupas, Denny Moyer, Stan Harrington, and Downes after his 40th birthday. (Pugilistica.com collection.)

Robinson prepares himself for his London fight with Downes. Both were former world champions when Downes took a decision over Robinson in 1962. Robinson's loss to Downes pretty much ended his days as a top fighter. He fought on for another three years, engaging in an additional 38 bouts. In all he fought 202 times, losing only 19. He dropped a decision to Joey Archer in his last bout. (Pugilistica.com collection.)

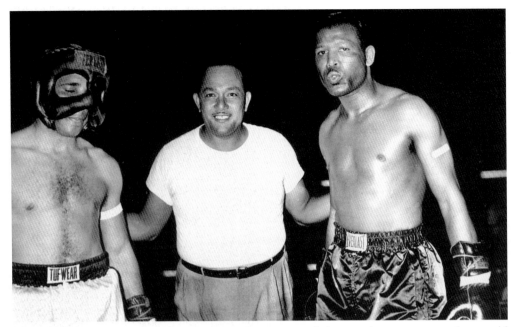

Even against an old Ray Robinson, sparring partners needed as much protection as they could get. The full face protection afforded by this head gear assures a hard-hitting pro that his sparring partners will be able to last the duration of training camp. Robinson rates seventh on the all-time knockout list with 110. (Pugilistica.com collection.)

Joey Giardello was born in Brooklyn's Bedford Stuyvesant section. His family later moved to Bergen Beach, where he grew up. Giardello later moved to Philadelphia. Giardello defeated Dick Tiger in 1963 to become champion. He successfully defended against Rubin "Hurricane" Carter, winning by the wide scores of 70-67, 71-66, and 72-66. Giardello dreamed about playing for the Brooklyn Dodgers and frequently worked out with the club.

Dick Tiger won both the middleweight and light heavyweight titles. After a short stay in England, he moved to New York and became a legend. Possibly the strongest middleweight ever, Tiger became involved with the Biafran movement in Nigeria and was banned by the Nigerian government. He stayed in New York, working security at a museum before developing liver cancer. He was allowed back into Nigeria just before he died.

A native of the Virgin Islands, Emile Griffith moved to New York City as a child. As a teenager he worked at a hat factory where one hot summer day he took off his shirt to cool down. His boss, who happened to be a prominent boxer manager, was so impressed by Griffith's physique that he insisted Griffith take up boxing. Griffith was trained by Gil Clancy and Howie Albert. (Pugilistica.com collection.)

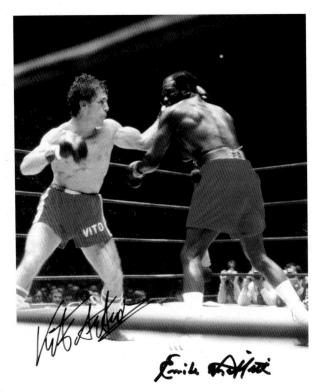

Vito Antuofermo was born in Bari, Italy. He moved to New York and fought Eddie Mustafa Muhammad in the New York Golden Gloves finals. He won the title in 1979 and successfully defended the title with a draw against Marvin Hagler. Antuofermo, who cut easily, also had to overcome a bad right heel. He hustled his way to wins over Emile Griffith (right), Denny Moyer, Hugo Corro, and Bennie Briscoe.

Before achieving superstardom as an actor, Brooklyn's Tony Danza was an aspiring middleweight. He was discovered by a television producer while working out and eventually retired from the ring to concentrate full time on acting. Danza rarely talks about his boxing career, but his record suggests he carried a serious wallop. All of his wins were by knockout, including one over the experienced Johnny Heard. (New York Daily News, Richard Corkery.)

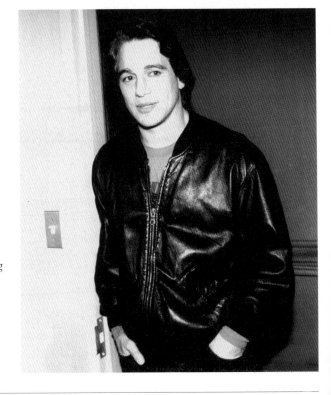

THE MIDDLEWEIGHTS

Davey Moore of the Bronx was a dynamic fighter who won the junior middleweight title after only eight fights. He was never given a chance to develop, and his promoters accepted any offer from anywhere in the world. They sent him to Japan, South Africa, Monaco, and France. Moore managed three successful defenses before losing the title to Roberto Duran. He beat Wilfred Benitez and Ayub Kalule.

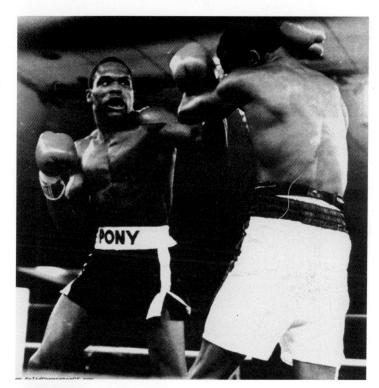

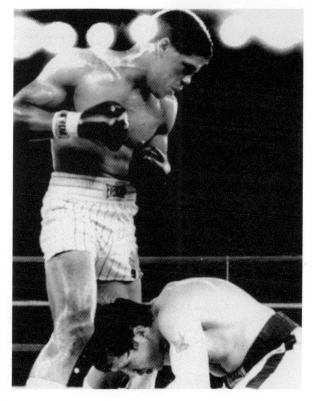

Alex Ramos of the Bronx was a four-time Golden Gloves champion who would have represented the United States in the 1980 Olympics had the games not been boycotted by President Carter. He beat J. B. Williamson, Norberto Sabater, and Curtis Parker and challenged Jorge Castro for the world title. He also formed the Retired Boxers Foundation, which came to the aid of several retired boxers who needed assistance. (Alex Ramos, Retired Boxers Foundation.)

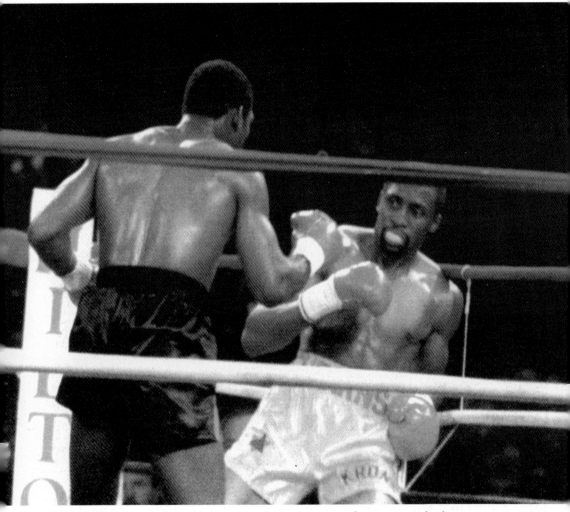

Iran Barkley grew up in the Bronx and as a youngster hung out with the same street gang as Mitch Green. He earned his title shot the hard way, fighting tough contenders like James Kinchen, Robbie Sims, Mike Tinley, and Wilford Scypion. He lost to Sumbu Kalambay in his first title shot but came right back with a win over top-rated Michael Olajide. He then scored a terrific knockout over Thomas Hearns in a bout he was close to losing due to a severe cut. He later added the super middleweight and light heavyweight championships. Iran was a fearless boxer who possessed a dangerous punch. He was an aggressive boxer who was never in a dull fight and never took a backwards step. He was introduced to boxing by his sister, Yvonne, who was a professional boxer. As great a fighter as Barkley was, he always claimed that his sister could kick his butt.

Although Mike McCallum's nickname was "the Body Snatcher," he could snatch one's head as well. Born in Kingston, Jamaica, and living in Flatbush, McCallum won the junior middleweight, middleweight, and light heavyweight titles. He defeated Donald Curry, Milton McCrory, Jeff Harding, and Steve Collins. He also represented Jamaica at the 1976 Olympics. McCallum, who was avoided for much of his career, is enshrined in boxing's hall of fame.

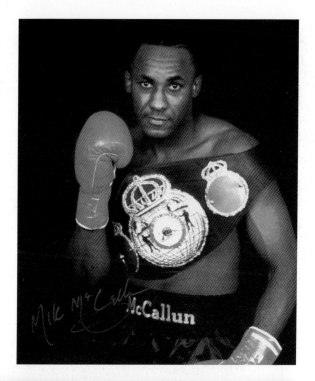

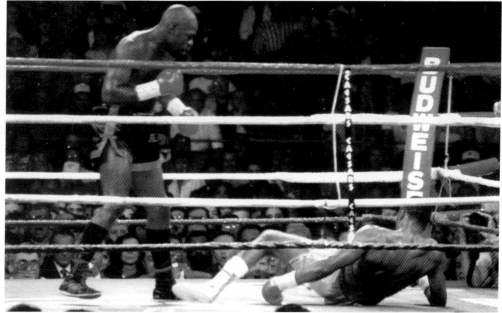

Iran "the Blade" Barkley twice beat Thomas Hearns. He also defeated Michael Olajide, Darrin Van Horn, Gerrie Coetzee, and Wilford Scypion. A three-division champion, he fought from middleweight up to heavyweight. Among the other boxers he fought were Michael Nunn, Roberto Duran, Nigel Benn, Trevor Berbick, and James Toney. He boxed in Canada, Finland, Germany, Australia, and Denmark.

Dennis Milton of the Bronx won the Golden Gloves four times. As a pro he got the better of Gerald McClellan, Michael Olajide, and Robbie Sims. He lost to knockout artist Julian Jackson in a bid for a middleweight belt. He also fought Bernard Hopkins and Aaron Davis. Milton was also a talented magician.

Michael Olajide Jr. came to New York via Canada and quickly established himself as the hottest prospect in the division. He twice fought for the world championship including a close loss to Tommy Hearns. A popular television attraction, he also enjoyed success as a model. Olajide became a respected personal trainer and invented the highly effective training method known as Aerobox. (NY Daily News, Craig Warga T.)

4

The Welterweights

The welterweight division has a weight limit of 147 pounds. It was first recognized in the United States in the 1880s when Paddy Ryan claimed the championship. It originally had a weight limit of 142 pounds. The name is derived from horse racing. Jockeys were fitted with a 28-pound weight called a welter, and with the weight, most jockeys weighed in at about 142 pounds. Nine locals have claimed the 147-pound championship. Another six grabbed the 140-pound junior welterweight title, which was first recognized in 1922. The first welterweight champion was Matty Matthews in 1900. The first boxer with ties to New York to win the junior welterweight crown was Mushy Callahan in 1926.

Soldier Bartfield, originally from Austria, boxed out of Brooklyn and topped 220 fights against the likes of Harry Greb, Ted Lewis, and Jack Britton. Sailor Burke was involved in many great battles, the most notable against Willie Lewis in 1909. They traded knockdowns in the first and second rounds, and then in the third round, they landed simultaneously and produced a double knockdown. The bell rang, saving them from a count out, and Lewis went on to win in the sixth round.

Canada Lee was a fine battler who neared 100 fights before an eye injury forced his retirement. He then became one of the top actors in America appearing both in film and onstage. He was active in the civil rights movement and this made him a target of McCarthyism, and subsequently he was blacklisted.

Other exciting fighters who made their mark over the years include Willie Beltram, whose exciting style of fighting usually produced multiple knockdowns, both his and his opponents, in each fight. Eugene Hairston, who was nicknamed "Silent" because he was deaf and mute, scored wins over Kid Gavilan, Paddy Young, and Paul Pender. He also fought a draw with Jake LaMotta. Gene Burton fought close to 90 fights and got the better of Tommy Campbell, Ike Williams, Bernard Docusen, and Johnny Bratton. Vince Shomo won numerous amateur titles and as a pro beat Isaac Logart and Charley Scott. He later became the comptroller for *Ring* magazine. Harold Weston Jr. was a top contender throughout the 1970s. He beat Vito Antuofermo and Rocky Mattioli and boxed draws with Wilfred Benitez and Saoul Mamby.

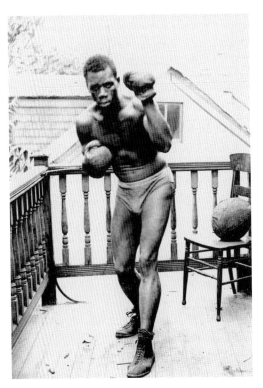

Welterweight Jack Young poses outdoors in this rare photograph. Notice the large striking bag on the chair behind him. It appears to be either a large speed bag or a double-end bag. Not much is known about Young, and his complete record is unavailable. (Pugilistica.com collection.)

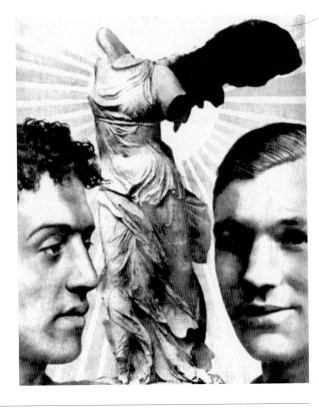

The French promoters used beautiful, artistic posters to promote their boxing matches. This poster for Harry Lewis's title defense against Willie Lewis (right) featured the Greek goddess Nike. The extremely popular Willie played a major role in helping to popularize boxing in France. He is credited with popularizing the left-right combination, throwing it so fast, they seemed to land simultaneously. He boxed Joe Gans, Dixie Kid, Mike Gibbons, and Stanley Ketchal. (Pugilistica.com collection.)

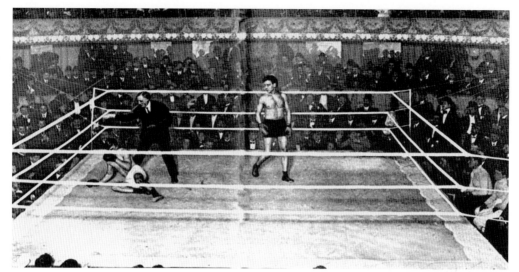

Willie Lewis, wearing white, and Harry Lewis met a total of three times, including a pair of 25-round draws in France. Their first fight took place on February 19, 1910, and the rematch took place on April 23, 1910. The fights were held at the Cirque De Paris and were gala affairs with an elaborately decorated, plush-lined ring with velvet draping. Boxing was just beginning to gain popularity in France, and both Willie and Harry were among a handful of Americans who made regular appearances there. Willie came from New York's rugged gashouse district. He later managed fighters and tended bar at Pete Moran's tavern. He died in 1949 in New York's Polyclinic Hospital. Harry was born Harry Besterman in New York and later moved to Philadelphia. He was champion from 1908 until 1911. (Pugilistica.com collection.)

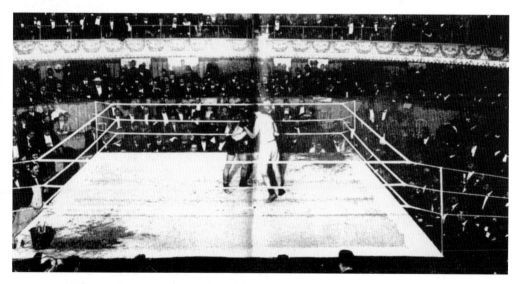

This illustration is from a poster used to promote the Jack Britton–Benny Leonard title fight. Britton was the welterweight champion and Leonard was the lightweight champion when this bout took place at the Velodrome in the Bronx on June 13, 1922. Leonard was winning the fight handily when he deliberately fouled out in Round 13. He claimed that he had no use for the welterweight title. (Pugilistica.com collection.)

Andy DiVodi of Brooklyn won close to 100 fights during his career. He challenged Mushy Callahan for the junior welterweight championship in 1927. DiVodi was the first boxer to beat Vince Dundee. In all, he met nine world champions. Notice in the picture that the corner post and ropes lack the padding of today's boxing rings. (Pugilistica.com collection.)

Mushy Callahan was born in New York and later moved out to California. He won the junior welterweight championship in 1926 and held it until 1930. Callahan was a master boxer who beat Ace Hudkins, Jimmy Goodrich, Andy DiVodi, and Tod Morgan. He later became a Hollywood consultant and choreographed fight scenes for several movies. He worked with James Earl Jones and Errol Flynn, Kirk Douglas, and Elvis Presley. (Pugilistica.com collection.)

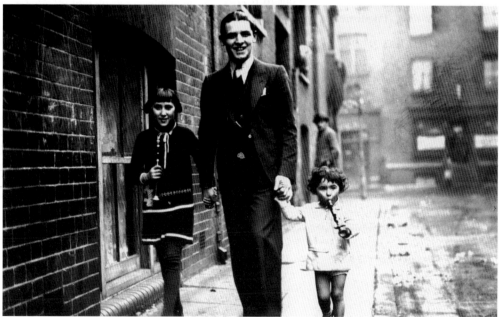

Jackie "Kid" Berg is seen here holding the hands of his sister and niece in White Chapel. Berg had mixed results when he first came to America in 1928. The following year, he set up headquarters in New York and went on to become a huge hit. He defeated Mushy Callahan, Tony Canzoneri, and Billy Petrolle and became the first to beat Kid Chocolate. (Pugilistica.com collection.)

Jackie "Kid" Berg beat junior welterweight champion Mushy Callahan over 10 rounds at London's Royal Albert Hall on February 18, 1930. The recently created division was not yet accepted by all, among them Lord Lonsdale, who stood up during the introductions and shouted that the division did not exist. Berg ended Callahan's five-year reign as junior welterweight champion. Callahan was born in New York City on November 3, 1905. He moved out to California at a young age and developed into one of the more technically sound boxers of his day. His technique was such that many Hollywood producers would seek his advice for their boxing movies. He helped choreograph several boxing films including *The Great White Hope* and *Champion*, where he taught James Earl Jones and Kirk Douglas how to box and move like real boxers. (Pugilistica.com collection.)

Barney Ross was born in New York and later moved to Chicago. He lost only 4 of 81 bouts. Ross won titles in three divisions and fought 16 title bouts. He beat Tony Canzoneri, Jimmy McLarnin, Billy Petrolle, Ceferino Garcia, and Izzy Jannazzo. Ross joined the Marines during World War II and was injured during a battle at Guadalcanal. He was also awarded a Silver Star. (Pugilistica.com collection.)

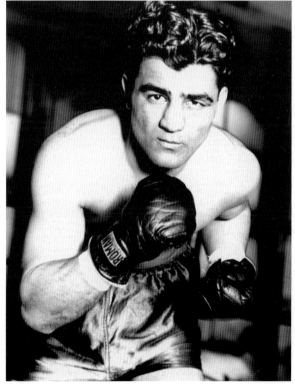

Izzy Jannazzo won the Maryland version of the world title in 1940, beating the excellent Puerto Rican Cocoa Kid. Jannazzo took on fighters most contenders avoided. He fought Holman Williams, Bee Bee Wright, Eddie Booker, and Dave Clark. He boxed Ray Robinson four times. He also battled Barney Ross, Solly Krieger, Kid Azteca, Stanislaus Loayza, Murray Brandt, and Fritzie Zivic. Jannazzo often boxed much heavier opponents. (Pugilistica.com collection.)

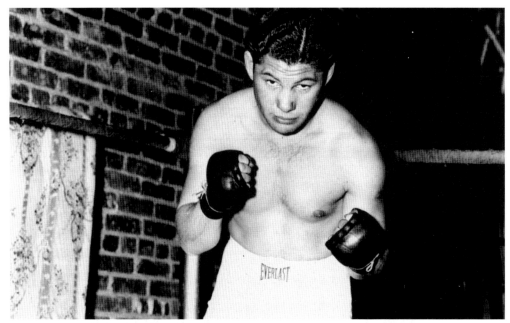

Welterweight Al "Bummy" Davis of Brownsville created a stir with his vicious punching power and fouling. He won his first 37 bouts, including a win over Tippy Larkin. He is the only fighter to knockout Tony Canzoneri. Davis fought Bob Montgomery, Beau Jack, Henry Armstrong, Fritzie Zivic, and Rocky Graziano. He died in 1945 fighting off three gunmen who were robbing a pub he was at. (Pugilistica.com collection.)

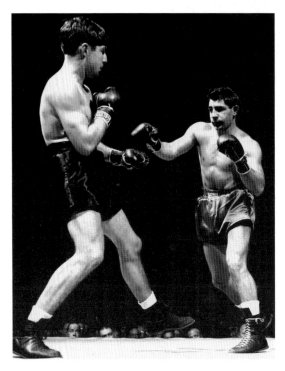

Bobby Ruffin of Astoria met Johnny Greco of Canada three times during 1944 and 1945. Greco won their first fight and Ruffin the last, with the second a draw. Ruffin was the son of Teddy Hubbs, who boxed Benny Leonard. Ruffin had over 130 fights and beat Beau Jack, Riche Lemos, Mike Belloise, and Chalky Wright. His fight against Willie Beltram headlined the first show at the Eastern Parkway Arena. (Pugilistica.com collection.)

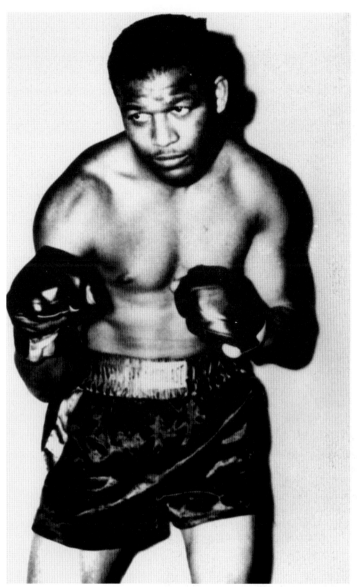

Walker Smith Jr. was born in 1921 and moved to New York at a young age. He entered a tournament using his friend's identification and became known as Ray Robinson. He turned pro as a lightweight on October 4, 1940. He was a top-10 lightweight within a few months. After running his record to 20-0, he took on reigning lightweight champion Sammy Angott. He outboxed the champion, but since he weighed 136 pounds, which was one pound over the limit, he could not claim the title. After stopping Maxie Shapiro on September 19, 1941, he moved up to welterweight. Robinson turned pro on the undercard of the Fritzie Zivic–Henry Armstrong title bout. When Robinson saw Zivic foul and batter his idol, he vowed revenge. On October 31, 1941, he got it, pounding out a decision. By 1941, Robinson was the best welterweight in the world, but he did not get a shot at the title until 1946, when he and Tommy Bell, the only welterweight willing to face him, fought for the vacant title. (Pugilistica.com collection.)

Billy Graham fought from 1941 until 1955. He was born on September 9, 1922, in New York. He went unbeaten in his first 58 fights. He fought a total of 126 fights in both the welterweight and middleweight divisions. He scored victories over Carmen Basilio, Ted Christie, Tony Pellone, Ruby Kessler, Willie Beltram, Kid Gavilan, Paddy Young, and Joey Giardello. Graham was never stopped or floored in his career. (Pugilistica.com collection.)

"In this corner . . . from Greenwich Village . . ." was how Tony Pellone used to be introduced. He headlined 17 bouts at Madison Square Garden. He used his brother's identification and turned pro at age 15. An exciting brawler, he was only a teenager when he fought the likes of Ike Williams, Bob Montgomery, Billy Graham, Charlie Fusari, Tony Janiro, and Johnny Greco. He also boxed Kid Gavilan, Johnny Saxton, and Joe Miceli.

The dapper Ray Robinson poses on his Lincoln Continental in front of his storefront office in Harlem. He also had a pink Cadillac that he loved to cruise around town in. Flashy in and out of the ring, Robinson turned to entertainment after he retired in 1952 with only three losses in 136 fights. He debuted as a tap dancer at the French Casino nightclub. (Pugilistica.com collection.)

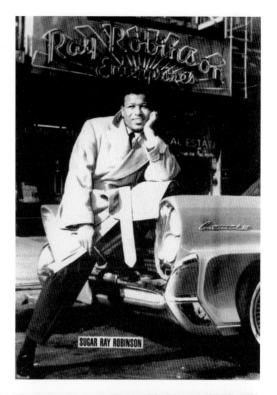

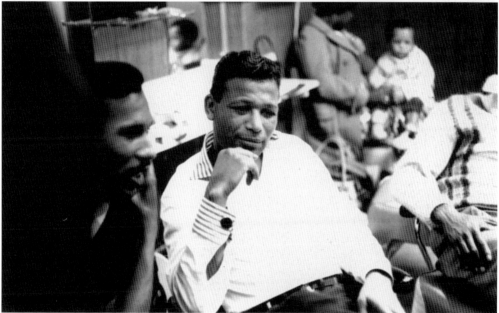

Robinson was known as a tough negotiator. He was the first boxer who negotiated to get a percentage of the television proceeds. Robinson owned several business enterprises throughout Harlem, including a popular café. Robinson later moved to Los Angeles and formed the Sugar Ray Robinson Youth Foundation. Robinson died in Los Angeles on April 12, 1989. (Pugilistica.com collection.)

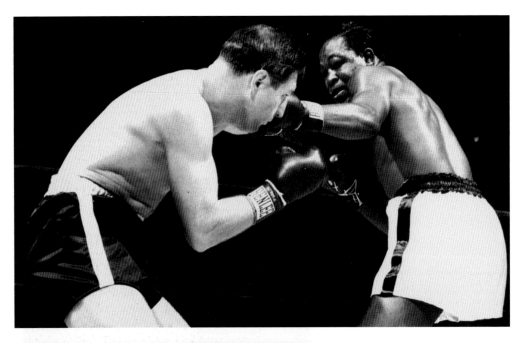

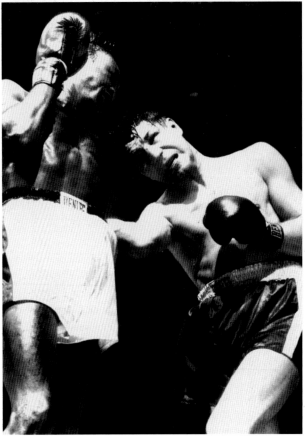

Champion Kid Gavilan (white shorts) mixes it up with Billy Graham during their 1951 championship bout at the Garden. Most people felt that Graham had done enough to earn the decision, but Gavilan was awarded a split decision. Graham was dubbed the "uncrowned champion" after this fight. After beating Johnny Cesario, Jimmy Herring, and Carmen Basilio to lead into an October 5, 1952, rematch with Gavilan in Cuba, Gavilan won a clear-cut 15-round decision at Havana's Stadium Ball Park. Many years later, one of the judges of their 1951 title fight admitted that the fight was fixed for Gavilan to win. Billy Graham was subsequently recognized by the New York State Athletic Commission as champion during the period between their two fights. (Pugilistica.com collection.)

Kid Gavilan takes a hard right from Billy Graham. Gavilan had 143 fights and was never stopped. He battled some of the biggest punchers of his time like Ray Robinson, Ike Williams, Carmen Basilio, Johnny Bratton, Beau Jack, Gil Turner, and Tony DeMarco. Gavilan, born Gerardo Gonzalez in Cuba, was one of the most popular fighters on the New York scene during the 1940s and 1950s. (Pugilistica.com collection.)

Carmine Fiore of Brooklyn's Greenpoint section was a contender throughout the 1950s. His father died when Carmine was still attending PS 17 elementary school. He worked shining shoes as a nine year old after school in order to help support his family and later was a truck driver. He boxed on television several times. An excellent athlete, he was a legend throughout local softball fields.

NEW YORK CITY'S GREATEST BOXERS

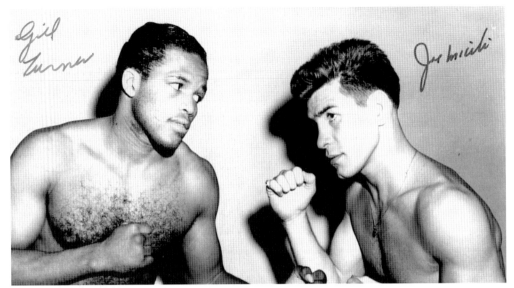

Joe Miceli of New York's Little Italy section squares off with Gil Turner. He was known as an offensive fighter, but he knew how to duck a punch as well. What he did not know how to duck were other fighters. He had 110 fights from 1948 until 1961, several against champions. He defeated Johnny Saxton, Ike Williams, Virgil Akins, and Wallace Bud Smith and drew with Joey Giardello.

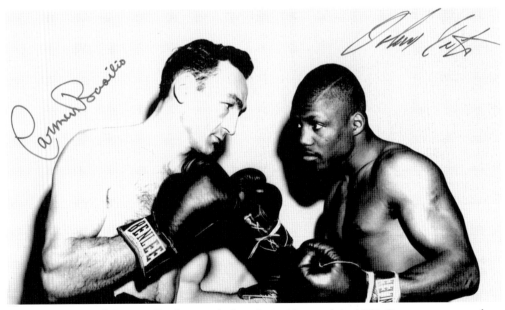

Johnny Saxton and Carmen Basilio pose before their title match in 1956. Saxton was an orphan who grew up in Brooklyn. For a while he was billed as the "Fighting Orphan." He moved up the ranks quickly, beating Joe Miceli and Tony Pellone within his first year. He beat Kid Gavilan to become champion in 1954. He won and lost the title again in 1956 against Basilio. (Heavyweightcollectibles.com.)

Emile Griffith, trainer Sid Martin, Sugar Ray Robinson, and manager Howie Albert pose while in Vienna in 1962. Griffith and Robinson boxed on the same card on October 17. Robinson stopped Diego Infantes in the second round, and Griffith won the junior middleweight title with a 15-round decision over Teddy Wright. (Pugilistica.com collection.)

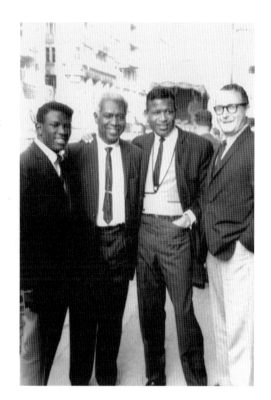

Emile Griffith was born in the Virgin Islands on February 3, 1938. He came to New York at age 11. He turned pro in 1958 and became a six-time champion in three different weight classes. He won the welterweight title three times and the middleweight championship twice. He was also junior middleweight champion. He later became a trainer and worked with Bonecrusher Smith, Wilfred Benitez, and Juan LaPorte. (Pugilistica.com collection.)

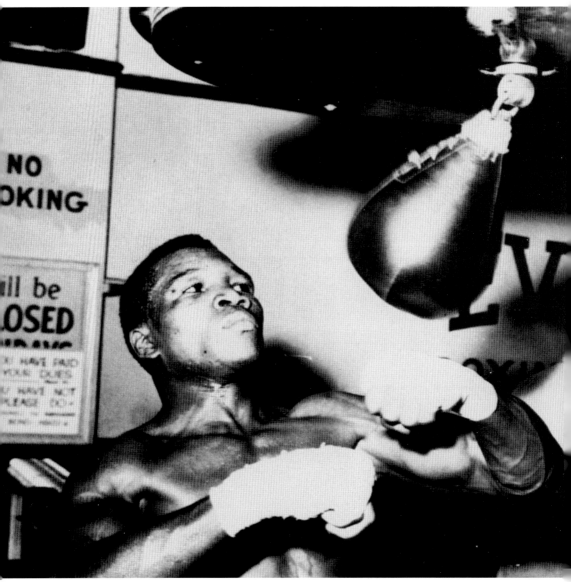

Benny "Kid" Paret came over to New York from Santa Clara, Cuba, in 1958. He settled in the Bronx and came out of Gleason's Gym. He became a two-time welterweight champion and challenged Gene Fullmer for the middleweight title. Paret was well known for being able to take a lot of punishment, and his management never thought twice about matching him tough. He won the title from Don Jordan and lost it to Emile Griffith. He regained the belt from Griffith and then lost to Fullmer in a brutal 10-round brawl, which saw Paret floored three times. Three months later, despite complaining of headaches, he fought a rubber match with Griffith. The fight was televised nationally and was viewed by millions. It was another bruising battle, which saw both men hit the deck. Griffith trapped Paret in a corner in the 12th round and unleashed a barrage of blows to knock out Paret. Paret died 10 days later from injuries sustained in the bout. He was only 25. (Pugilistica.com collection.)

Isaac Logart was among the many Cuban boxers who left Cuba after Fidel Castro banned professional sports. Logart settled in New York and wrapped up his 18-year career with 111 fights. Here he is seen knocking out Duke Harris in seven rounds in 1956. He beat Virgil Akins, Gil Turner, Joe Miceli, Tomas Lopez, Gasper Ortega, and Ramon Fuentes. (Pugilistica.com collection.)

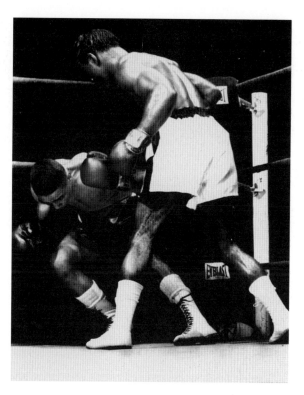

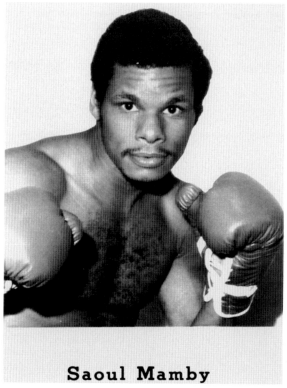

Saoul Mamby

Saoul Mamby was one of the best defensive boxers. His craftiness allowed him to box for 31 years until the age of 53. The Vietnam veteran boxed the likes of Roberto Duran, Antonio Cervantes, Esteban DeJesus, James McGirt, and Bill Costello. He also fought draws against Edwin Viruet and Harold Weston, two outstanding New Yorkers. He held the junior welterweight title from 1980 until 1982, successfully defending it five times.

Mark Breland was perhaps the greatest amateur ever produced by America. A five-time Golden Gloves champion, he was a gold medalist at the 1984 Olympics. As a pro he twice held the WBA title and defeated champions Lloyd Honeyghan and Rafael Pineda and held the great Marlon Starling to a draw. The Brooklyn resident has enjoyed success as an actor. He also is a well-regarded dog trainer.

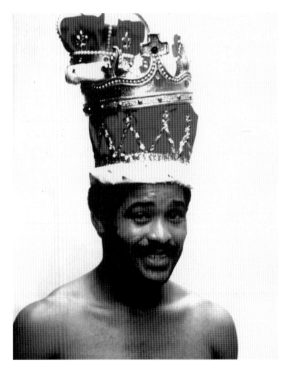

Wilfred Benitez was born in the Bronx. He grew up, and still lives, in Puerto Rico. Benitez was a defensive wizard who had the ability to anticipate punches before they were thrown. He became the youngest champion ever when, at age 17, he defeated Antonio Cervantes to win the junior welterweight title. He later added the welterweight and junior middleweight titles.

5

THE LIGHTWEIGHTS

A total of nine boxers from New York City have laid claim to ruling the 135-pound lightweight division. Jack McAuliffe was the first to reach championship status. Benny Leonard was next, and he was so dominant that many championship-quality boxers could not win the title. Among them were the Cross brothers, Leach and Marty. Leach's 41-round fight against Dick Hyland is the fourth-longest bout where the contestants wore boxing gloves. Willie Fitzgerald had more than 150 bouts against all the big names.

Throughout history, lightweights were among the sport's biggest attractions. Tony Canzoneri, Jimmy McLarnin, Barney Ross, Henry Armstrong, Lou Ambers, and Beau Jack attracted thousands of fans to their fights. Televised boxing caused live attendance to drop considerably over the next few years, but Carlos Ortiz once again began to draw huge crowds.

The many outstanding contenders from the city who provided memorable moments include Kid Herman, who once floored the great Benny Leonard. He later became president of the Newsdealers' Association and operated a newsstand in the heart of Times Square. Carlos Ortiz was one of the best ever.

Johnny Busso defeated a pair of hall of famers in Joe Brown and Carlos Ortiz. Edwin "Chu Chu" Malave made headlines when he and his brother were co-champions of the Golden Gloves. Edwin Viruet boxed Roberto Duran and Esteban DeJesus. His brother, Adolfo, also fought Duran as well as Sugar Ray Leonard. John Verderosa of Staten Island made headlines in the early 1980s with his big punching, and Vilomar Fernandez was as clever as they come.

The junior lightweight division, with a top weight of 130 pounds, was first established in 1920, and up until 1933 boxers actively competed for the championship. The division was then ignored but resurfaced during the late 1950s and has existed since. Five New Yorkers have captured top honors in this weight classification, also known as super featherweight, the first being Jack Bernstein in 1923.

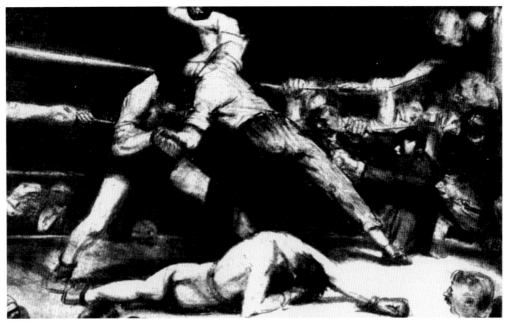

Jack McAuliffe, known as "the Napoleon of the Prize Ring," was champion from 1886 until 1894. This sketch shows him on the floor against Jem Carney. Fans rushed the ring after he went down, and the bout was called a draw after 74 rounds. He retired undefeated. He was a protégé of nonpareil Jack Dempsey, the former middleweight champion. Both fighters' careers overlapped the bare-knuckle era. (Pugilistica.com collection.)

Knockout Brown was one of the first of the prolific knockout artists. He won most of his fights by knockout. At the time of his retirement in 1916, he rated in the top five among all-time knockout leaders. A southpaw, he scored a first-round knockout over "Harlem" Tommy Murphy and boxed against Phil Bloom, Leach Cross, Abe Attell, and Ad Wolgast. (Pugilistica.com collection.)

New York's Leach Cross was a lightweight contender who fought from 1905 to 1921. Cross was a contender for the title for almost an entire decade and ended his career with a total of 151 fights. In his only chance at the world title, he fought to a 10-round no-decision against champion Willie Ritche in New York's Madison Square Garden on November 10, 1913. (Pugilistica.com collection.)

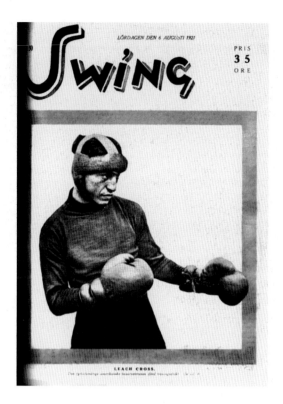

"Harlem" Eddie Kelly took on all of the great boxers of his time. The lightweight shared a ring with Benny Leonard, Mickey Walker, Lew Tendler, Matt Wells, Rocky Kansas, and Charley White. He defeated "Fighting" Dick Hyland and Walter Mohr in his 100-plus fight career. Kelly boxed from 1911 to about 1922. (Pugilistica.com collection.)

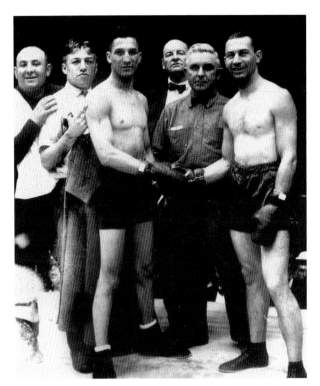

Lew Tendler and Benny Leonard shake hands before their 1923 title match. Leonard defended successfully against Tendler by a decision after 15 rounds. The previous year, Tendler was talked out of a victory by Leonard. He hit Leonard with a punch that froze him. Unable to move, Leonard complained that he was fouled. Tendler defended himself and that split second was all the time Leonard needed to clear his head. (Pugilistica.com collection.)

Augie Pisano had over 150 fights during his career. He boxed from 1922 until 1932 and competed in every division from flyweight up to lightweight. He boxed against Al Singer, Benny Bass, King Tut, Bruce Flowers, Babe Herman, Eddie "Cannonball" Martin, Ruby Goldstein, Pal Silvers, and Stanislaus Loayza, as well as Steve Halaiko. (Pugilistica.com collection.)

Benny Leonard lost much of his money and investments during the stock market crash. He made a comeback but was nowhere near the fighter he used to be. He became a referee. On April 18, 1947, he died while refereeing a fight between New Yorker Bobby Williams and Mario Roman of Los Angeles at the St. Nicholas Arena. He collapsed during the first round and later died of cardiac arrest. (Pugilistica.com collection.)

Leonard gives Nathan Straus a big hug during a 1926 Hakoah soccer match at New York's Polo Grounds. The Hakoah team was known for fielding an all-Jewish squad. The game attracted over 45,000 spectators including Straus, who along with his brother Isidor was co-owner of Macy's, the department store. Isidor died on the ill-fated *Titanic*, after reportedly saving several lives. Nathan Straus was also a generous philanthropist. (Pugilistica.com collection.)

More than 22 years in the ring led to 250-plus bouts for Brooklyn's Joe Glick. One of the best to never win a title, Glick challenged for the title three times. He lost twice to Tod Morgan and to Jackie Berg. He was beating Morgan in their 1927 fight but fouled out in Round 14. He also swapped blows with Tony Canzoneri, Jimmy McLarnin, and Jack Bernstein. (Pugilistica.com collection.)

Stevie "Kid" Sullivan was born on May 21, 1897, in Brooklyn, New York. He was managed by Andy Niederreiter, who later promoted fights in Ebbets Field. Sullivan beat Johnny Dundee on June 20, 1924, in Brooklyn. He defended the title against fellow New Yorker Vincent "Pepper" Martin and Mike Ballerino before losing the title to Ballerino in April 1925. (Pugilistica.com collection.)

Steve "Kid" Sullivan of Brooklyn defeated the great Johnny Dundee in 1924 to become junior lightweight champion of the world. He successfully defended the title twice. Sullivan fought a total of 109 times against the very best of his time including Babe Herman, Vincent "Pepper" Martin, Mike Ballerino, and Louis "Kid" Kaplan. Sullivan boxed from 1911 through 1926. (Heavyweightcollectibles.com.)

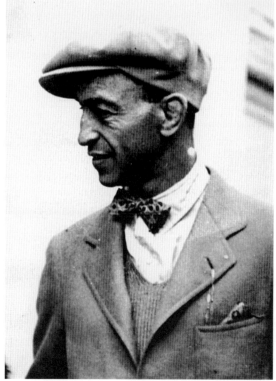

Leach Cross, known as the "the Fighting Dentist," was indeed a practicing dentist. He was known to offer free dental work to several of his opponents and designed his own mouthpiece. His real name was Louis C. Wallach. He boxed against the very best of his time and scored victories over Battling Nelson, Ad Wolgast, "Mexican" Joe Rivers, "Harlem" Tommy Murphy, and Knockout Brown. (Pugilistica.com collection.)

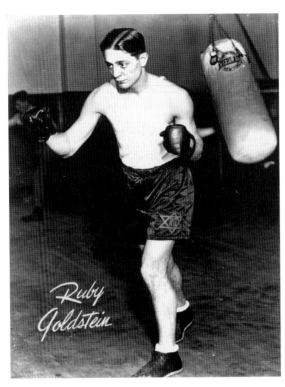

According to those who saw him, lightweight Ruby Goldstein was a sight to behold. A fantastic boxer, he mesmerized spectators with his fabulous moves. An extremely popular boxer, the hearts of his many fans where broken when he was stopped by the "Nebraska Wildcat," Ace Hudkins, in four breathtaking rounds. He beat Jimmy Goodrich, Cuddy DeMarco, and Pete Zivic. Goldstein's only weakness was his durability, with all of his losses being by the knockout route.

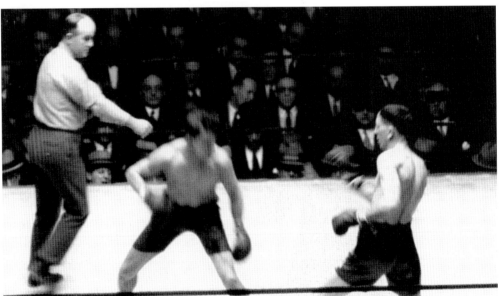

Sid Terris is moving so fast that he appears to be a blur in this photograph. He was too fast for European champion Lucien Vinez, outscoring him over 10 rounds before 15,000. Terris never fought for a championship but beat many champions, including Johnny Dundee, Jimmy Goodrich, and Jack Bernstein. Terris's knockout of Ruby Goldstein in Round 1 came just seconds after he was dropped for a nine count. (Pugilistica.com collection.)

Henry Goldberg of Brooklyn was one of the many exciting fighters campaigning in the city during the 1920s. He mixed it up against Eddie Whalen, Harry Ebbets, and Andy DiVodi. He fought from lightweight up to middleweight. He and Joe Marino of Staten Island hooked up for a memorable clash in 1926. He also fought Gorilla Jones and Paul Pirrone. (Pugilistica.com collection.)

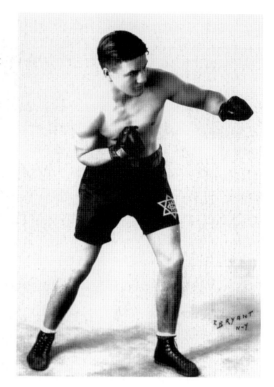

Al Singer was lightweight champion from July 17, 1930, until November 14, 1930. He crushed the clever Sammy Mandell in one round to win the belt and lost it the same way to Tony Canzoneri. Singer boxed 72 times and scored many of the best-scoring wins over Carl Duane, Andre Routis, and Eddie Martin. (Pugilistica.com collection.)

Al Singer poses with his manager, Hymie Caplin. Hymie and his brother, Dan, operated a gym in the Lower East Side. Hymie managed several top-notch fighters like Lew Jenkins and Sid Terris. Singer is notoriously known as the champion who won and lost his title on first-round knockouts. (Pugilistica.com collection.)

Tony Canzoneri squares off with Singer before their November 14, 1930, title fight. Canzoneri scored a one-round knockout. After boxing, Canzoneri became an actor and operated a farm in Upstate New York. He was co-owner of Tony Canzoneri's Paddock Bar and Grill on Broadway. He died of a heart attack in a room at the Hotel Bryant where he was living. He was found two days later.

Al Roth turned pro in 1931 and went unbeaten in his first 26 bouts. He challenged Canzoneri for the lightweight title on October 4, 1935, losing a 15-round decision. He beat Freddie "Red" Cochrane and Battling Battalino during his 89-fight career. He also boxed Beau Jack, Lou Ambers, Mike Belloise, and Baby Arizmendi. (Pugilistica.com collection.)

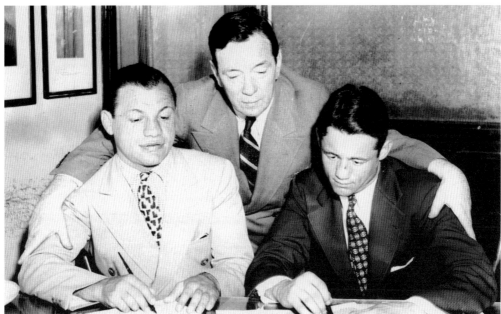

Canzoneri signs for his lightweight title match against Lou Ambers while Mike Belloise signs for his featherweight title defense against Dave Crowley. The matches took place on the same September 3, 1936, card at Madison Square Garden. Belloise stopped his foe in nine rounds while Canzoneri lost his belt to Ambers over the 15-round distance. (Pugilistica.com collection.)

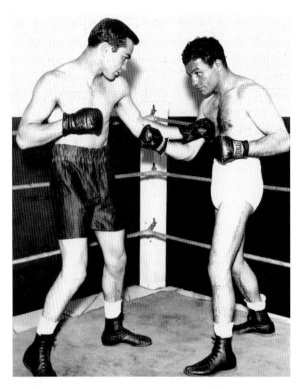

Barney Ross and Tony Canzoneri size each other up before their 1933 title bout. Ross beat him twice that year with the lightweight title on the line. The first bout took place in Chicago, and Ross won an unpopular decision. The rematch was over 15 rounds in New York and saw Canzoneri lose three rounds because of low blows. (Pugilistica.com collection.)

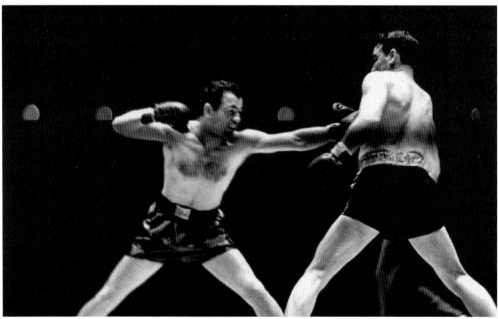

Canzoneri lands a left to the midsection of Jimmy McLarnin. They fought twice in 1936, with Canzoneri winning the first and McLarnin the rematch. Beau Jack is often credited with fighting the most main events at Madison Square Garden with 21, but the ring record book lists 23 main events for Canzoneri. (Pugilistica.com collection.)

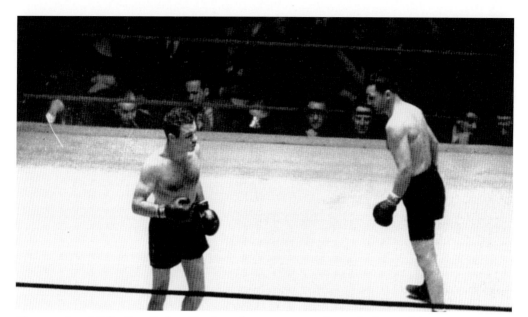

Canzoneri and Billy Petrolle head back to their corners at the end of one of the 25 rounds they fought against each other. Petrolle beat him the first time, and Canzoneri gained revenge over 15 rounds in their 1932 championship bout. Canzoneri fought in 22 championship bouts from 1927 until 1937. (Pugilistica.com collection.)

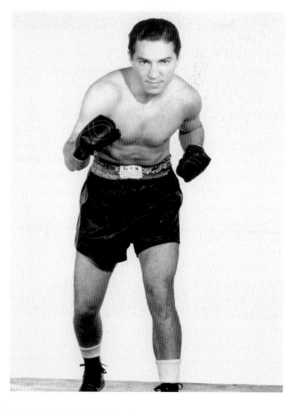

Maxie Shapiro was a top contender for an entire decade. He got started late, turning pro in 1938 at age 24. By the end of the following year he was a top attraction. He went 37-0 before dropping a decision to rugged Al Reid. He scored wins over Bob Montgomery, Sal Bartolo, Chester Rico, and Al Penino. He also fought Henry Armstrong and Ray Robinson in his 125-fight career. (Pugilistica.com collection.)

NEW YORK CITY'S GREATEST BOXERS

Tony Canzoneri locks horns with Jackie "Kid" Berg during their 1931 title bout. Most of the fight was fought at close quarters with Canzoneri getting the nod after 15 furious rounds. Berg beat Canzoneri the previous year over 10 fast-paced rounds in New York. Canzoneri also scored a three-round knockout over Berg in 1931. (Pugilistica.com collection.)

Lou Ambers came from Herkimer, New York, and moved to New York to further his career. He came to the city with nothing and had no place to stay. He often slept on park benches. He was discovered at a fight in Brooklyn by Al Weill, who managed him all the way to the lightweight championship. Ambers beat Henry Armstrong, Tony Canzoneri, Baby Arizmendi, and Fritzie Zivic. (Pugilistica.com collection.)

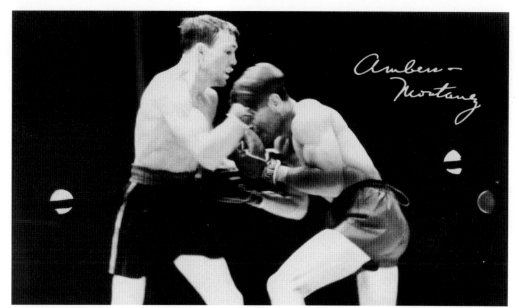

Ambers got revenge over Pedro Montanez in their rematch on September 23, 1937. The fight was the main event of the Carnival of Champions card that featured four of boxing's eight champions defending their titles. Montanez beat Ambers the previous April in a non-title bout and was the favorite going into the rematch. But Ambers clearly beat Pedro and ended his 61-bout unbeaten streak in the process. (Pugilistica.com collection.)

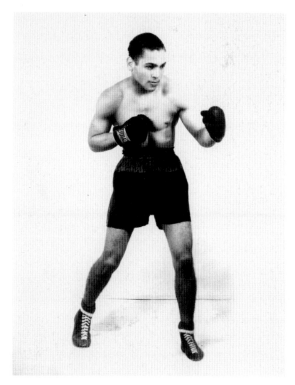

Montanez was a popular attraction during the 1930s. Nicknamed "El Toro," after the mountains of his hometown, Cayey, Puerto Rico, he dazzled fans in both Europe and America. An aggressive fighter with good power, he went unbeaten in over five years. He scored victories over Lou Ambers, Frankie Klick, and Jackie Berg and challenged Henry Armstrong for the welterweight title. Montanez split his time between Puerto Rico and Queens.

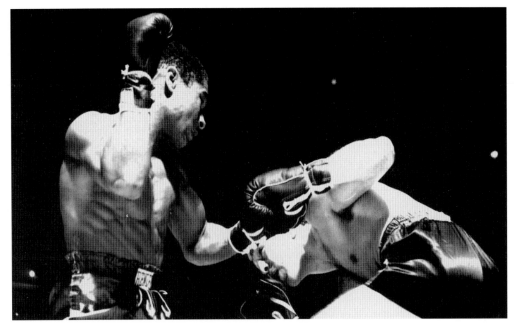

Beau Jack is on his way to stopping Allie Stolz in the seventh round of their November 13, 1942. Jack is often credited with headlining the most main events in Madison Square Garden with 21. Stolz, from Brooklyn, was one of the bigger attractions of the 1940s. Many felt he beat Sammy Angott when they fought for the title in 1942. Stolz also fought Bob Montgomery for the title.

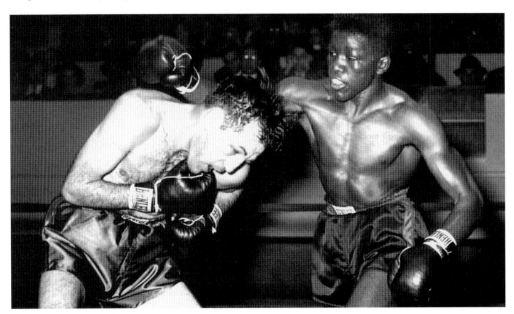

Chester Rico was near the end of his career when he ducked this right hand from Canadian Arthur King in 1948. Rico, a 100-fight veteran, belongs to that group of excellent contenders who never got a crack at the title. He bested Leo Rodak, Maxie Shapiro, Freddie Archer, Al Penino, and Mike Belloise and fought Jack to a draw. He later became a trainer. (Pugilistica.com collection.)

Humberto Zavala squares off against Danny Bartfield before their 1945 bout at the Garden. Bartfield floored Zavala twice en route to winning a 10-round decision. He also won a decision over Zavala in 1947. Bartfield was a highly regarded prospect during the 1940s. He beat Monty Pignatore, Joe Echevarria, and Joey Fontana and boxed Paddy DeMarco, Terry Young, and Willie Joyce. (Pugilistica.com collection.)

Lulu Constantino of Brooklyn was unbeaten in his first 56 fights. His first loss was to reigning champion Chalky Wright in 1942. They fought again four months later with the title on the line. Lulu lost a 15-round decision. He beat Chalky in 1943, but Chalky was an ex-champion by then. Lulu finished with over 130 fights and beat Harry Jeffra and Joey Archibald. (Pugilistica.com collection.)

Three-time champion Jimmy Carter was born in Aiken, South Carolina, on December 15, 1923. He lived in Pennsylvania for a short time before moving to New York City, where he lived in the Bronx and Ozone Park. He turned pro in 1946 after military service in Europe and the Philippines. He won the title from Ike Williams in 1951 and won and lost it against Lauro Salas in 1952.

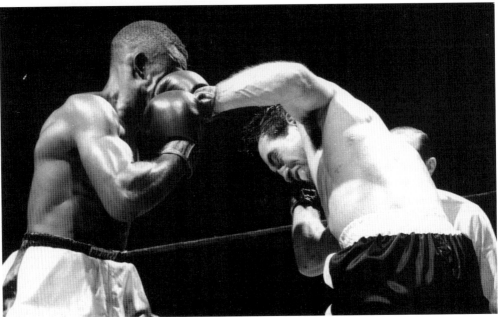

Paddy DeMarco lands a left hook to the face of champion Jimmy Carter. DeMarco took the title from Carter on March 5, 1954, with a 15-round decision. DeMarco hailed from Brooklyn's navy yard area and fought a total of 104 fights in his 15-year career. DeMarco was also a singer and performed on television several times. (Pugilistica.com collection.)

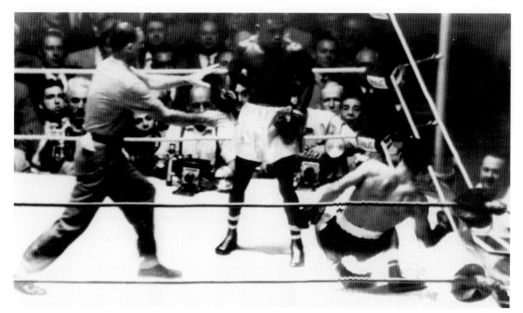

Jimmy Carter regains the title with a 15-round stoppage of DeMarco. The bout took place at San Francisco's Cow Palace on November 17, 1954. It was often said that there were two Jimmy Carters because of his propensity for losing and then coming back to win the rematch. It happened with Art Aragon, Armand Savoie, Lauro Salas, and again with DeMarco. (Pugilistica.com collection.)

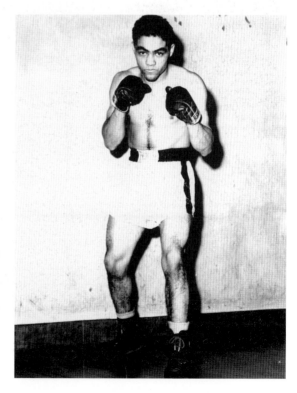

Frankie Narvaez was a top contender for most of his nine-year career. He beat Joe Brown, Chango Carmona, Carlos Teo Cruz, and Pedro Adigue. He also boxed Flash Elorde, Ismael Laguna, and Ken Buchanan. The decisions against him in his fights against Laguna and Elorde were so unpopular that they each caused riots to break out. Narvaez, a Puerto Rican, also boxed in England and France.

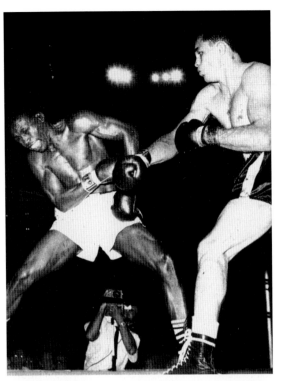

Carlos Ortiz defeated longtime champion Joe Brown to win the title. He also held the junior welterweight title. Ortiz, who is in the hall of fame, could do it all inside in the ring, brawling and boxing with equal success. He scored wins over Ismael Laguna, Duilio Loi, Flash Elorde, and Sugar Ramos. The Puerto Rican–born Ortiz boxed in Japan, Mexico, the Philippines, the Dominican Republic, Europe, and South America.

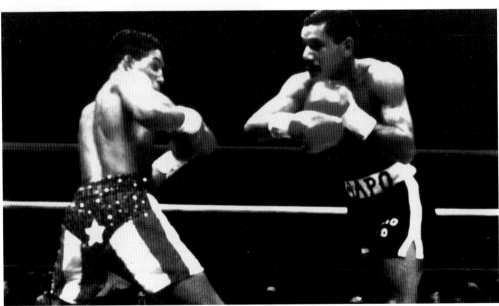

Hector Camacho barely escaped with a decision over Edwin Rosario in their June 13, 1986, title bout in New York. It was a thrilling fight that pitted Rosario's thunder against Camacho's lightning. Spectators were split on who they thought won. After the brawl, the dynamic Camacho forever converted into a safety-first boxer. He remained an attraction, but many of the cheers were replaced by jeers.

6

The Featherweights

When Woodville Latham and his sons, Grey and Otway, first demonstrated their invention, the Eidoloscope, which was the first movie projector, they chose as their first subjects New York City featherweight Charley Barnett and former champion Young Griffo. Barnett did not accomplish much as a boxer, but at least his moment of fame was longer than the allotted 15 minutes.

Terry McGovern was the first New Yorker to win the 126-pound championship. Many expected a long reign, but his demise came quickly. McGovern was an ex-champion by 1901. "Brooklyn" Tommy Sullivan became champion in 1904 with a knockout over Abe Attell. Sullivan had more than 114 bouts in his career.

Jack Skelly became the first boxer to challenge for a title in his professional debut, losing to George Dixon. The Packey O'Gatty–Frankie Burns fight was the first fight in the United States to be broadcast on radio. O'Gatty fought over 100 fights plus more than 1,000 exhibitions for U.S. troops during World War I. Willie Jackson came into prominence after scoring a first-round knockout of Johnny Dundee. Dundee was hit so hard that he thought he won the fight. It was in his dressing room that he realized he had lost. Leo Johnson, a black fighter from Harlem, once went 50-plus bouts without an official loss.

Other popular fighters included Tommy Abobo, Nicky Jerome, Al Reid, Bernie Friedkin, and Joey Fontana. Flatbush's Pete DeGrasse approached 200 fights, and Petey Hayes floored Kid Chocolate four times. Frankie Covelli scored 100 wins while fighting the best.

Among the most heroic of all boxers was Julie Bort, despite having been stricken with polio as a child. He ran off 12 consecutive wins during 1947 and defeated Lulu Constantino and Pete Martin. There was also Carl Palumbo, whose promising career was cut short due to injuries sustained in World War II. Best known as a trainer, Victor Valle lost only twice in his career. Tito Valles was an active campaigner and, more recently, Tyrone Jackson challenged for the title.

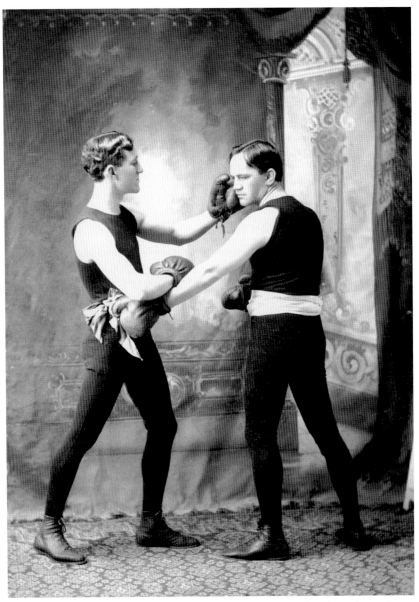

"Harlem" Tommy Murphy and New York lightweight Patsy Broderick strike a classic pose in this studio photograph. Murphy was a top contender in both the featherweight and lightweight divisions. He challenged Abe Attell in 1905 for the 126-pound title and in 1914, challenged Willie Ritchie for the 135-pound championship. He finished with some 150 fights and took on the likes of Terry McGovern, Packey McFarland, Leach Cross, Ad Wolgast, and Owen Moran. He was indirectly responsible for giving Bob Ripley of *Believe It or Not* fame his start. When Murphy went to San Francisco to challenge Ritchie, part of his entourage included New York *Globe* editor Walter St. Denis. St. Denis was approached by the 19-year-old Ripley, who had with him a bunch of drawings, including one he did of Tommy Murphy. Ripley joined the staff as a sports cartoonist a few months later. (Pugilistica.com collection.)

Ireland's Johnny Drummie fought out of Brooklyn and took on the toughest fighters in his division. Benny Leonard, Johnny Dundee, Willie Jackson, George "KO" Chaney, and Patsy Cline were among his opponents. He boxed from about 1913 up until about 1922. His fight against all-time great Johnny Kilbane in 1917 was a bitterly contested 10-round affair won by Kilbane. (Pugilistica.com collection.)

Johnny Dundee decided to become a boxer after meeting "Gentleman" Jim Corbett while still a youngster. He was working at his father's fish market on Forty-second Street next to the stage entrance of the American Theatre where Corbett was performing in *The Burglar and the Lady*. Corbett pulled up in his car and asked Dundee to guard it. Dundee started boxing immediately after that. (Pugilistica.com collection.)

NEW YORK CITY'S GREATEST BOXERS

JOHNNY DUNDEE
Holder of Two Titles

Johnny Dundee had more than 330 fights between 1910 and 1932. In 1911, his first full year of boxing, he fought 47 times, which just may be a record. He fought a disputed draw with Johnny Kilbane for the featherweight title in 1913. Dundee was then avoided by the champion, waiting 10 years before getting another shot at the title, beating French war hero Eugene Crique. He was also junior lightweight champion. Dundee was a fast boxer who moved as though on a pogo stick. He was well known for bouncing off the ropes while throwing a punch to give them more effect. He was stopped only once in his career. Dundee often fought out of his weight class, taking on the top lightweights. He boxed Benny Leonard eight times, flooring him in one of their fights. He also boxed Charley White, Lew Tendler, Rocky Kansas, Willie Ritchie, Freddie Welsh, and Tony Canzoneri. Other boxers he fought included Eddie "Cannonball" Martin, Vince "Pepper" Martin, and Kid Sullivan. He was elected into the International Boxing Hall of Fame. (Pugilistica.com collection.)

Tony Canzoneri was born in Slidell, Louisiana, on November 6, 1908. He moved to New York as a teenager and went on to become one of the best. He won titles in the featherweight, lightweight, and junior welterweight divisions. He also fought the great Charles Bud Taylor to a draw for the bantamweight title, just missing becoming the first boxer to win titles in four weight classes.

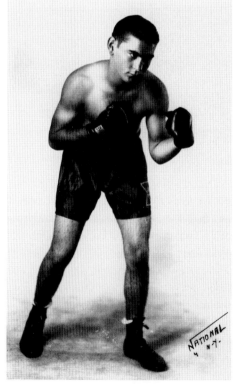

Brooklyn's Lew Feldman had close to 200 fights against some of the greatest boxers of all time. He beat Mike Belloise, Chalky Wright, Lew Jenkins, Midget Wolgast, Freddie Cochrane, and Battling Battalino. His two-title challenges are an oddity because the championships of two divisions were at stake. He challenged Henry Armstrong for both the welterweight and lightweight titles and Kid Chocolate for both the featherweight and junior lightweight belts. (Pugilistica.com collection.)

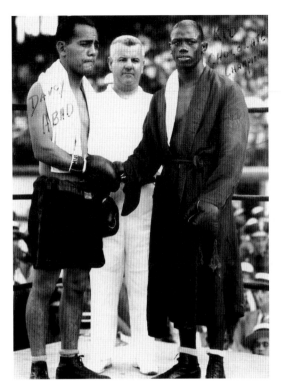

Davey Abad and Kid Chocolate shake hands prior to their 1932 title fight. The Kid successfully defended his belt by decision. Kid Chocolate came to New York after dominating Cuban boxing, and became one of the biggest stars ever. He lost only 10 times out of about 150 fights. He won titles as a featherweight and junior lightweight. Abad, from Ohio, fought most of his 110 fights in New York. (Pugilistica.com collection.)

Young Peter Jackson of the Lauren Hill section of Queens was a club fighter who was willing to take on anyone. He boxed frequently at the Ridgewood Grove and boxed several times in Montreal. He was the first boxer to defeat Petey Hayes. He fought several times against Pete De Grasse, a Canadian who lived in Flatbush. De Grasse approached 180 fights in his career. (Pugilistica.com collection.)

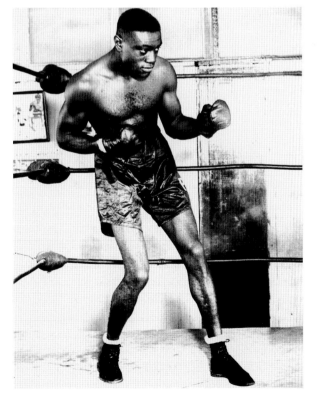

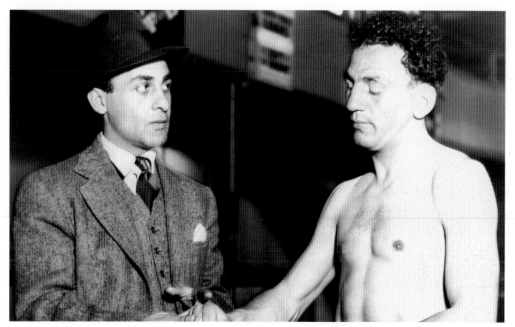

Danny London represents the quintessential club fighter. In shape and always ready, they were good fighters who fought at all the neighborhood fight clubs. When boxing started being televised, fans stopped going to the clubs and eventually they folded. The term "club fighter" is still used, but today it refers to someone who has no chance of winning. London totaled more than 125 fights, being stopped only three times. (Pugilistica.com collection.)

Petey Scalzo turned pro in 1936 and went unbeaten in his first 40 fights. The National Boxing Association appointed him champion on May 1, 1940, after his knockout of Ginger Foran. He defended against Brooklyn veteran Frankie Covelli, Poison Ivy, and Phil Zwick and lost the belt to Richie Lemos. He beat Joey Archibald, Al Reid, Sal Bartolo, Simon Chavez, Allie Stolz, and Mike Belloise. (Pugilistica.com collection.)

Phil Terranova got into boxing because of his older brother Frankie, who had more than 100 fights. Phil came out of Gleason's Gym and went on to become champion in 1943, stopping Jackie Callura in six. He lost the title to Sal Bartolo and later challenged Willie Pep for the world title. Phil, who stood five feet two inches, also campaigned in the lightweight division. He beat Sandy Saddler and Maxie Shapiro.

Sandy Saddler was born in Boston in 1926. He moved to Harlem when he was three. Saddler held the featherweight and junior lightweight titles simultaneously. His 103 knockouts place him in the top 10 of most career knockouts, first among featherweights. He was featherweight champion from 1948 until 1949, and again from 1950 until his retirement in 1956. He retired following an eye injury caused by a car accident.

The Belloise brothers, Mike and Steve, came out of the Bronx and enjoyed great success. Middleweight Sal was also a pro boxer who met quality foes such as Ernie Durando and Jimmy Flood. Mike, top photograph, was champion from 1936 until 1937. He won and lost his title out of the ring, having been appointed champion and then stripped of his title in August 1937. Mike boxed against Henry Armstrong, Lew Jenkins, Jackie Wilson, and Juan Zurita. Steve was a top middleweight who many people felt should have been champion following his title bout with Ken Overlin on November 1, 1940. Steve had Ken down, but the decision went to Overlin. They fought a rematch six weeks later with the decision going again to the defending champion. (Pugilistica.com collection.)

NEW YORK CITY'S GREATEST BOXERS

SANDY SADDLER
Next Featherweight Champion
Mgr. Charles Johnston 1476 Bway., N.Y.C. Br 9-2350

Joe Sandy Saddler was originally billed as the "Harlem Scotchman." He was a star basketball player in high school. He started boxing as a flyweight, and after 17 amateur fights, he turned pro in 1944. He served in both the army and navy during World War II and the Korean War. He boxed in Mexico, Cuba, Panama, Venezuela, Aruba, France, England, and Argentina.

Pat Marcune of Brooklyn started boxing while serving in the Coast Guard. He was an aggressive and hard-hitting crowd favorite who boxed on television several times. He beat Lauro Salas, Bill Bossio, Tito Valles, and Charley Titone. He also boxed Willie Pep and Harold Gomes. Marcune worked as a diamond setter and jeweler and was also a well-regarded chess player. (Pugilistica.com collection.)

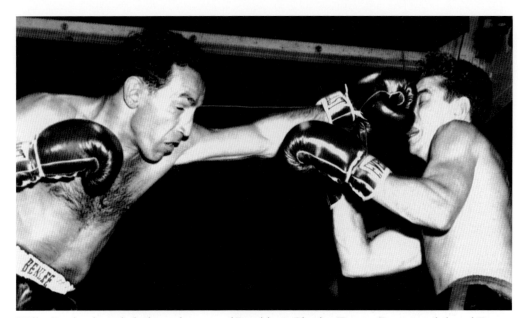

Willie Pep lands a jab flush on the nose of Brooklyn's Charley Titone. Pep twice defeated Titone over 10 rounds. Titone had more than 100 fights in his 15-year career. He also boxed against Carlos Ortiz, Pat Marcune, Bill Bossio, and Kid Anahuac. He beat Harry Lasane and Ritchie Howard. Titone boxed in Cuba, Canada, and Venezuela. (Pugilistica.com collection.)

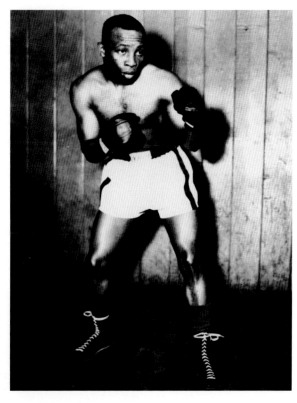

Ike Chestnut of Harlem was a leading contender for the latter half of the 1950s. He scored victories over Carmelo Costa, Doug Medley, Cecil Schoonmaker, Frankie Sodano, Kid Anahuac, and Lauro Salas. He was a popular attraction on the West Coast and fought in Panama, Mexico, Venezuela, Cuba, and Canada. He also boxed Flash Elorde, Harold Gomes, and Ricardo Moreno.

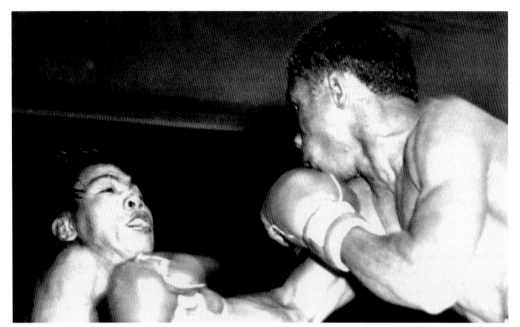

Miguel Berrios scores with a right to the jaw of future champion Flash Elorde. Berrios beat Elorde twice in 1956. Berrios, of Santurce, Puerto Rico, fought out of New York. He scored several big wins in a career cut short due to an eye injury. He beat Pat Marcune, Carmelo Costa, Kid Anahuac, and Ike Chestnut. (Pugilistica.com collection.)

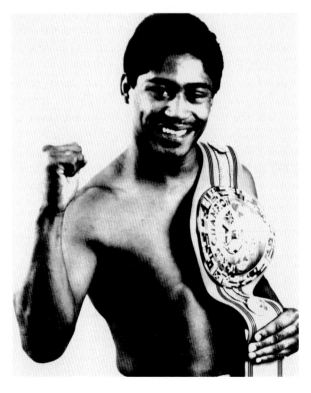

It has been said that Kevin Bacon is the hub of the entertainment universe because he can be linked to almost every film actor in no more than six steps. Juan LaPorte just may be the hub of the boxing universe. LaPorte can be linked from flyweight to heavyweight, from Muhammad Ali to Roy Jones Jr., and as far back as Willie Pep.

7

The Bantamweights

Bantamweights possess blazing speed and endless stamina and, with a top weight of 118 pounds, enough power to score knockouts. Some of the greatest fights ever were bantamweight bouts. Tommy "the Harlem Spider" Kelly was the first New York–born champion since the Marquis of Queensberry rules were adopted. Quite possibly the oldest of all weight classes, dating back to the early 1850s, several boxers claimed the title during the early years, but by 1890, when Kelly knocked out Chappie Moran in 11 rounds, one champion was recognized by most followers. Kelly remained champion for two years and boxed on and off until 1900. Also in 1890, Cal McCarthy fought a draw over 70 rounds with one of the greatest ever, George Dixon. Casper Leon, recognized as an American champion, was another New Yorker who approached greatness. He approached 90 bouts during his career.

Terry McGovern, born in Pennsylvania and reared in Brooklyn, was starting to develop a reputation that would last until today. Nicknamed "Terrible," he became champion with a 75-second knockout of clever British champion Pedlar Palmer in 1899. McGovern would later win the featherweight championship. His aggressive, hard-hitting style made him a hero. While his December 1900 win over Joe Gans is believed to have been fixed, McGovern's record is remarkable. Other outstanding bantams to come out of New York included Charley Goldman, who went on to become a great trainer, Abe Goldstein, Joe Lynch, Eddie Martin, and Lou Salica.

Many popular club fighters from the area gave fans much to cheer about with their action-packed fights. Brooklyn's Hilly Levine and Larry Goldberg, and from across the East River, Willie Spencer and Davey Brown, were among the many. Like the flyweights, after the 1930s bantamweights virtually vanished from the local scene. Cecil Schoonmaker did most of his fighting in California. Cecil scored wins over Dado Marino, Kui Kong Young, and Luis Castillo. Baby Davey Vasquez was North American Boxing Federation (NABF) champion during the 1970s and a few years later, Carmelo Negron made headlines with his string of knockouts. But New York would have to wait until Junior Jones before they could again call one of their own a champion.

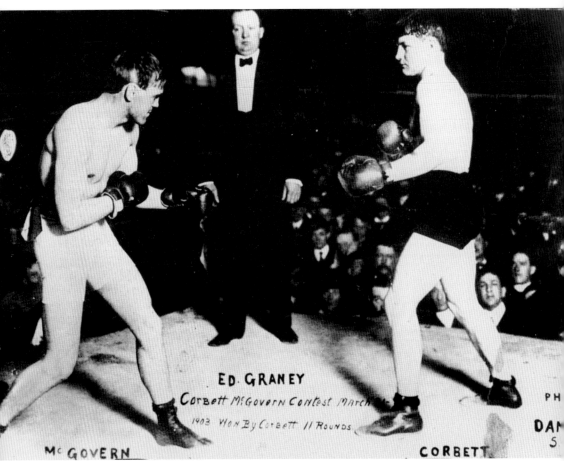

"Terrible" Terry McGovern squares off before his 1903 bout with Young Corbett II. McGovern failed in his bid to regain the title after 11 rounds. Corbett beat McGovern in 1901 to take the title. McGovern was champion in both the bantamweight and featherweight divisions and had a shot at Battling Nelson for the lightweight title. He scored wins over Pedlar Palmer, Harry Forbes, George Dixon, Aurelio Herrera, Casper Leon, Joe Bernstein, "Harlem" Tommy Murphy, Kid Broad, and Frank Erne. His second-round knockout over Joe Gans was later found out to be a fixed bout, with Gans taking a dive. The fight took place in 1900 at Chicago and led to boxing being outlawed in that city until 1926. McGovern was born in Johnstown, Pennsylvania, in 1880. His family came to Brooklyn when he was still a child. McGovern was also a talented baseball player who reportedly turned down offers to play professional baseball.

New York bantamweight Frankie Daly had more than a dozen fights against nine world champions. He fought against Frankie Genaro, Johnny Buff, Kid Williams, Carl Duane, Joe Lynch, and Abe Goldstein, among many others. Daly was one of the most durable fighters of his time, frequently fighting 10- and 12-rounders just a week apart. (Pugilistica.com collection.)

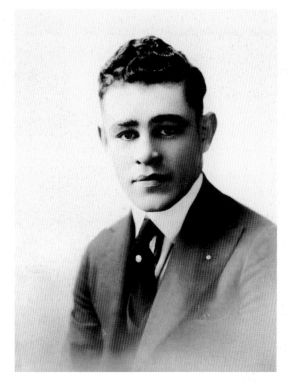

Dominick Petrone is proof positive that one cannot judge a fighter's skill by his win-loss record. Petrone lost almost as often as he won throughout his 100-fight career. But the Harlem featherweight was no easy pickings for anyone. He was good enough to beat "Panama" Al Brown, Carl Duane, and Abe Goldstein, and drew with Harry Forbes. (Pugilistica.com collection.)

Jeanne La Mar is often hailed as the first female boxing champion. She was a dancer who started to train at Stillman's Gym in order to strengthen her legs. She impressed many with the way she struck the bags and eventually started boxing, sparring many of the pros including, allegedly, Benny Leonard. La Mar sparred numerous exhibitions throughout the country, taking on all comers. (New York Daily News, Greene.)

Davy Brown was a busy campaigner during the 1920s and 1930s. From Harlem, Brown was a bantamweight who frequently fought heavier opponents. He boxed against the likes of Petey Hayes, Al Roth, Hilly Levine, and Danny London. Brown fought at all of the major fight clubs in Brooklyn that were in operation during his time. (Pugilistica.com collection.)

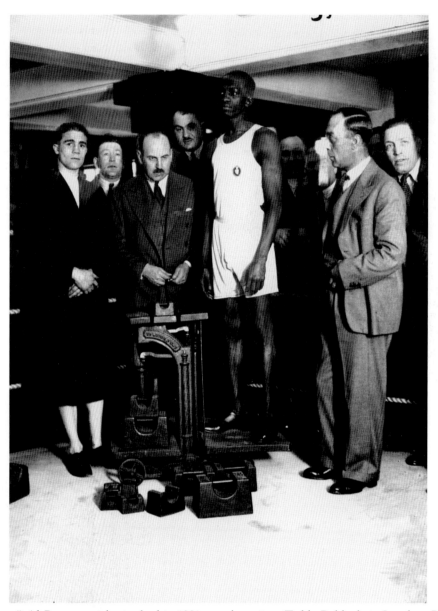

"Panama" Al Brown weighs in for his 1931 match against Teddy Baldock in London. Brown scored a 12-round stoppage over the former champion. Brown's early record in Panama is incomplete. He came to New York in 1923 and finished fighting in 1942. His known record is listed at 125 wins, with 55 of them by knockout. Brown became the first Latin American fighter to win a world championship. He did so on June 18, 1929, in New York. He held on to the title until 1935 and made a total of 10 defenses. His six-year reign is the longest of any bantamweight. Brown was never stopped in 155 fights and boxed from flyweight up to featherweight. He stood 5-feet-11-inches tall and never weighed more than 126 pounds for a fight. He was a big attraction in Europe and lived for a while in Paris. He returned to New York after his fighting days were over and died of tuberculosis in New York on April 11, 1951. (Pugilistica.com collection.)

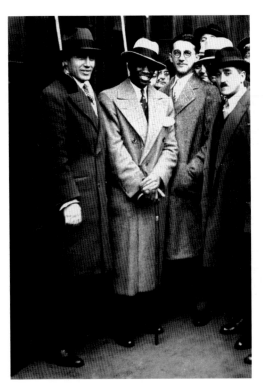

"Panama" Al Brown, second from left, boxed in Panama, France, Spain, Denmark, Cuba, England, Canada, Wales, Italy, Belgium, Algeria, Morocco, Switzerland, and Norway. He totaled 155 fights and boxed from 1922 until 1942. He beat Kid Francis, Pete Sanstol, Pinky Silverberg, Emile Pladner, and Eugene Crique. He lost his title to Baltazar Sangchilli in 1935 but beat him in a rematch three years later. (Pugilistica.com collection.)

Pete Sanstol was born in Norway in 1905. He turned pro in 1926 and went on to become one of the biggest attractions in the city, especially at the Ridgewood Grove. Sanstol also fought many times in Canada, and after being denied a title fight, the Canadian commission recognized Sanstol as world champion in 1931. Later that year he lost a decision to Brown for the undisputed title. (Pugilistica.com collection.)

Young Perez and Sanstol pose before their 1934 bout, which Sanstol won on points after 10 rounds. The fight took place in Norway, where Sanstol was born. Sanstol turned pro in 1926 and moved to New York the following year. Young Perez, a French Tunisian, was a former flyweight champion who was believed to have been killed by Nazis in a concentration camp. (Pugilistica.com collection.)

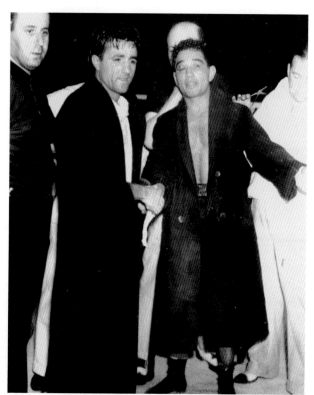

Despite closing the eye of Sixto Escobar, Lou Salica lost by a 15-round decision in San Juan, Puerto Rico. They fought a total of three times, with Salica winning the first and Escobar the second and third. Salica won the title from Sixto in 1935 and lost it back to him later that year. He again won the championship in 1940 and remained champion until 1942. (Pugilistica.com collection.)

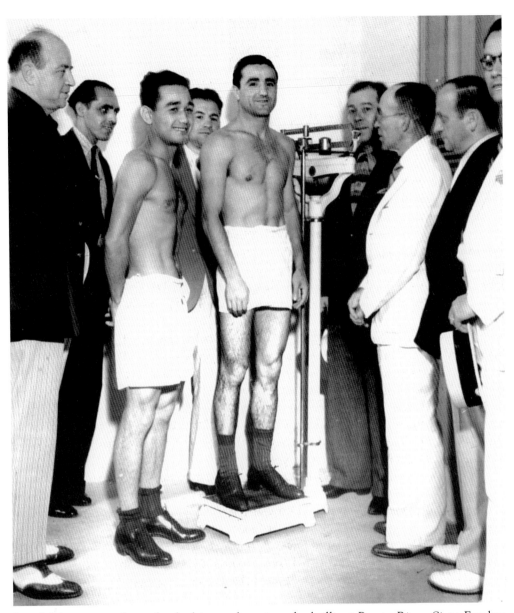

Lou Salica steps on the scales for his match against the brilliant Puerto Rican Sixto Escobar. Salica was a bronze medal winner as a flyweight at the 1932 Olympics. He turned pro later that year and fought a total of 91 fights, scoring 62 wins and fighting to a draw 12 times. He went the distance in all but one of his fights. Longtime champion Manuel Ortiz stopped him in 12 rounds in 1943. Salica won the world championship twice during his 12-year career. Among the outstanding fighters he fought were Manuel Ortiz, Georgie Pace, Small Montana, Harry Jeffra, Speedy Dado, and Midget Wolgast. He held off the challenges of Philadelphia's Tommy Forte and Lou Transparenti. Salica boxed in Cuba, Canada, and Hawaii and on both coasts of the United States. Salica was born on July 26, 1913, and was a stable mate of Al Singer. (Pugilistica.com collection.)

8

THE FLYWEIGHTS

The flyweight division was created in England in 1910 with the official weight limit being 108 pounds, later to become 112 pounds. America followed suit and officially recognized the division later that year. Before that, the lightest of boxers were forced to battle bantamweights. Although Jim Barry was billed as the 100-pound champion in 1897, the first universally recognized world champion of the division was Jimmy Wilde, of Wales, who stopped Brooklyn's Young Zulu Kid in 11 rounds in 1916. Young Zulu was born in Potenza, Italy, real name Guiseppe DiMelfi, and came to New York as a child. He started boxing in 1912 in Brooklyn. He had over 125 fights, mostly against bantamweights and featherweights. He also boxed for the American Flyweight title.

During the 1920s, New York was the center of world-class activity among flyweights, highlighted by New Yorkers Frankie Genaro, Corporal Izzy Schwartz, and New York–born Fidel La Barba. Other top boxers from the city included Pinky Brown and the Bronx's Jack Sayles. Battling Henry was billed as a bantamweight but weighed under the 112-pound flyweight limit for much of his career. The excellent Young Johnny Rosner of New York surpassed the century mark in total bouts and engaged Jimmy Wilde on April 24, 1916, for the International Boxing Union (IBU) title. Rosner won the American championship the following year. He and Zulu Kid boxed a total of eight times against each other.

A shift occurred during the 1930s as Europe and Asia became the center of activity. Competition and paydays for flyweights vanished from the city, and anyone less than 112 pounds was forced to travel abroad to make a living. In recent years, only Brooklyn's Henry Brent challenged for world honors in this division. Known as "Hot Pepper," he fought bantamweights as he climbed up the rankings. He won the United States Boxing Association championship twice, in 1982 and again in 1985. In 1986, he challenged Korean southpaw Hi Sup Shin in Cunchon, Korea, for the International Boxing Federation (IBF) world championship, losing in 13 rounds.

Jimmy Wilde and Little Jack Sharkey sign for their 1919 no-decision bout in Milwaukee. Wilde had only one official loss in more than 130 fights, but Sharkey appeared to get the best of him. Sharkey was born Giovanni Cervati in Bolgna, Italy, and turned pro in New York when he was only 15. (Pugilistica.com collection.)

Corporal Izzy Schwartz of New York, center, won titles in the flyweight and bantamweight divisions. He was flyweight champion from 1927 until 1929. Schwartz finished his career with 124 fights over 12 years. He beat Tommy Abobo, Newsboy Brown, French Belanger, and Johnny Breslin. He later was financial secretary for the moving picture projectors union for many years. (Pugilistica.com collection.)

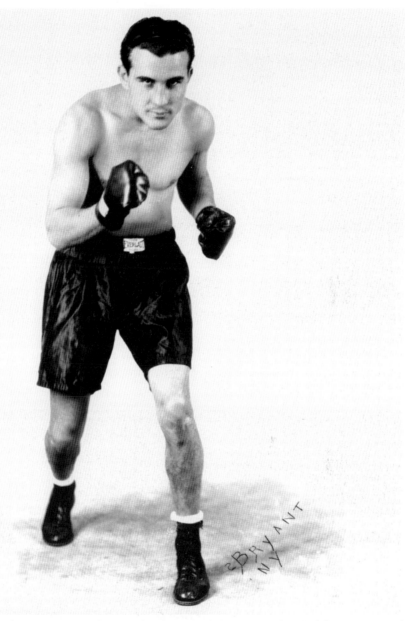

Fidel LaBarba was born in New York on September 29, 1905. He moved to California at an early age. He won a gold medal at the 1924 Olympics and was flyweight champion from 1925 until 1927, retiring undefeated as champion. He made a comeback shortly after and campaigned as a featherweight. He graduated from Stanford University and worked in journalism after his career. Fidel faced an extraordinarily high class of opposition throughout his career. In his second fight he met Jimmy McLarnin. After 13 months as a pro, he beat Frankie Genaro for the American title. He also beat Clever Sencio, Emil Paluso, Elky Clark, Johnny Vacca, Bushy Graham, Kid Chocolate, Tommy Paul, Bud Taylor, Battling Battalino, Baby Arizmendi, and Newsboy Brown. Fidel boxed in Australia and Mexico. He later served in the U.S. Army during World War II.

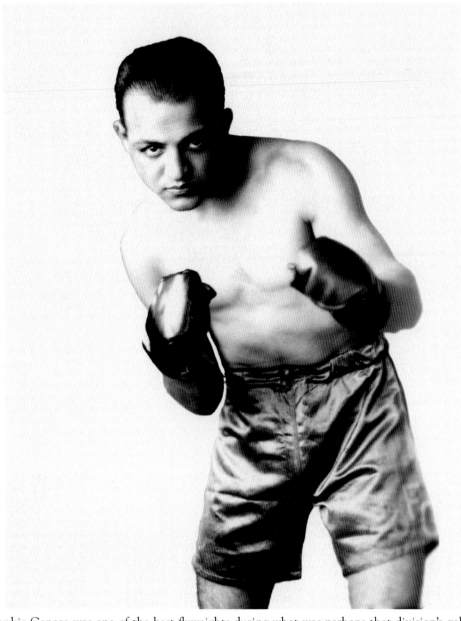

Frankie Genaro was one of the best flyweights during what was perhaps that division's golden era. He boxed from 1920 until 1934, engaging in a total of 131 matches. He won the American Flyweight title in 1923 and kept it until 1925. He won the National Boxing Association championship in 1928 and again in 1929, holding it the second time until 1931. Genaro was born on August 26, 1901, in New York City. Genaro started boxing at a young age and went on to represent the United States at the 1920 Olympic Games in Antwerp, where he won the gold medal. He is enshrined in the International Boxing Hall of Fame. Frankie had aspirations of being a jockey and even trained in that field. He also worked as truck driver for some time before turning pro. His real name is Frank Di Gennaro. (Pugilistica.com collection.)

Frankie and Emile "Spider" Pladner sign for their 1929 match. They boxed twice that year, both times in Paris. Pladner became the first fighter to knockout Genaro, doing so in one round on March 2. The rematch, on April 18, saw Genaro win by disqualification after five rounds. The flyweight title was up for grabs both times they fought. The French fans lost control and attacked Genaro and his cornerman as they left the ring. Genaro would go on to box four more times in Paris. He also boxed in Canada, England, Germany, Italy, and Spain. He defeated Carl Tremaine, Pancho Villa, Bushy Graham, Kid Williams, Frenchy Belanger, Johnny Vacca, Ernie Jarvis, Speedy Dado, Joey Archibald, and Valentin Angelmann. (Pugilistica.com collection.)

ACROSS AMERICA, PEOPLE ARE DISCOVERING SOMETHING WONDERFUL. THEIR HERITAGE.

Arcadia Publishing is the leading local history publisher in the United States. With more than 3,000 titles in print and hundreds of new titles released every year, Arcadia has extensive specialized experience chronicling the history of communities and celebrating America's hidden stories, bringing to life the people, places, and events from the past. To discover the history of other communities across the nation, please visit:

www.arcadiapublishing.com

Customized search tools allow you to find regional history books about the town where you grew up, the cities where your friends and family live, the town where your parents met, or even that retirement spot you've been dreaming about.